AUDREY HEPBURN IN HATS

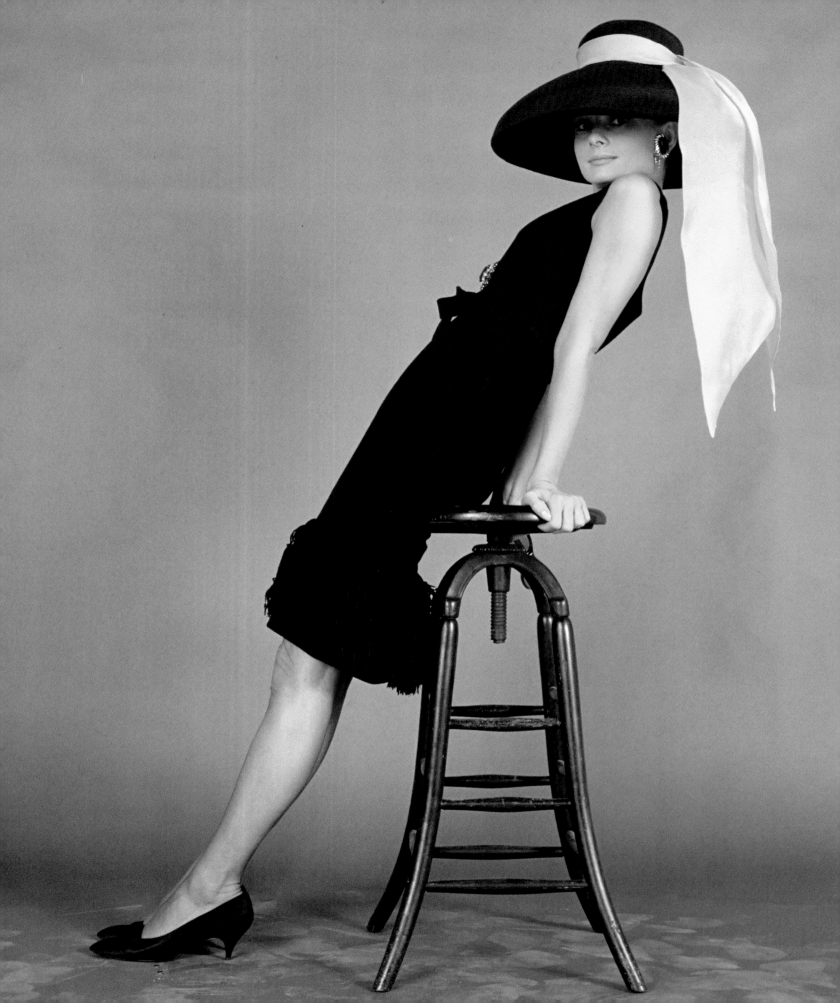

AUDREY HEPBURN IN HATS

JUNE MARSH

REEL ART PRESS

Author: June Marsh
Editor: Tony Nourmand
Art Director: Graham Marsh
Page Layouts: Jack Cunningham
Text Editor: Alison Elangasinghe

First published 2013 by Reel Art Press, an imprint of Rare Art Press Ltd., London, UK. www.reelartpress.com

ISBN: 978-1-909526-00-6

Printed in China

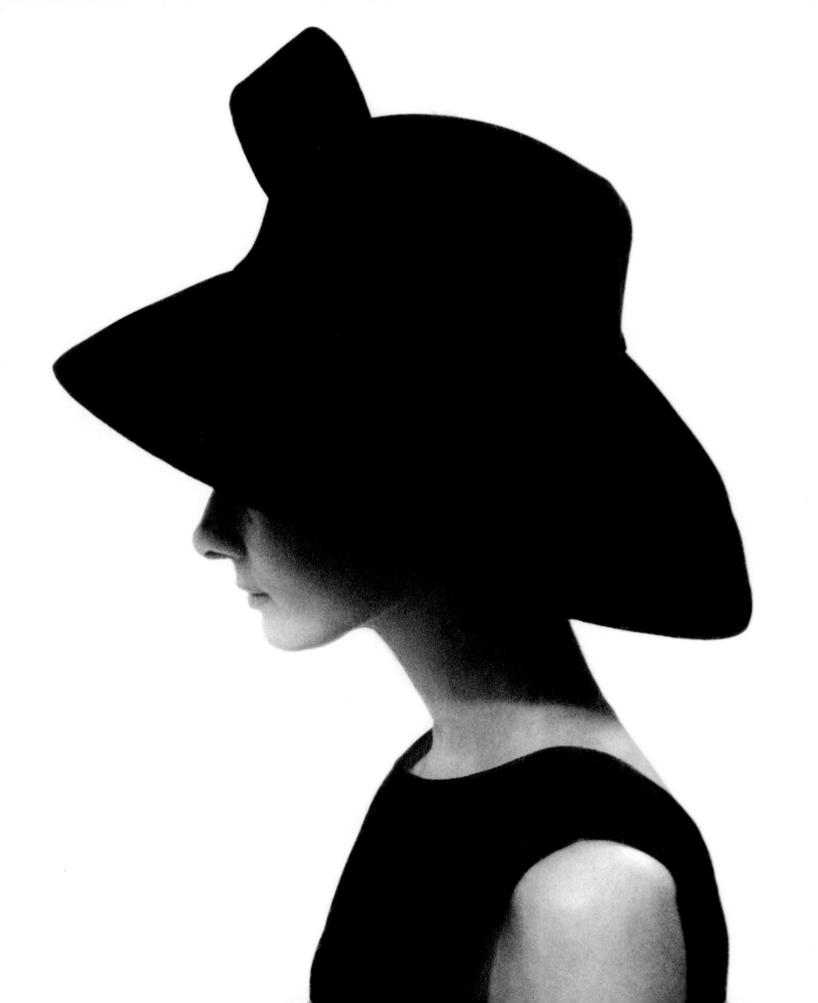

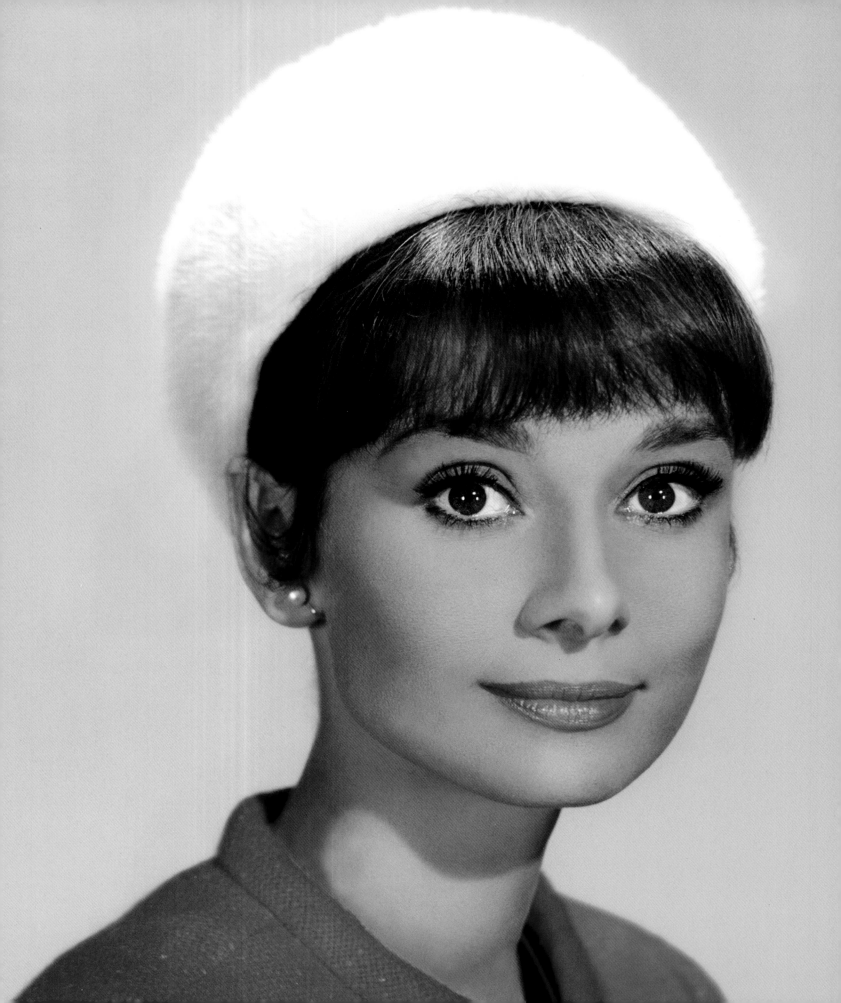

CONTENTS

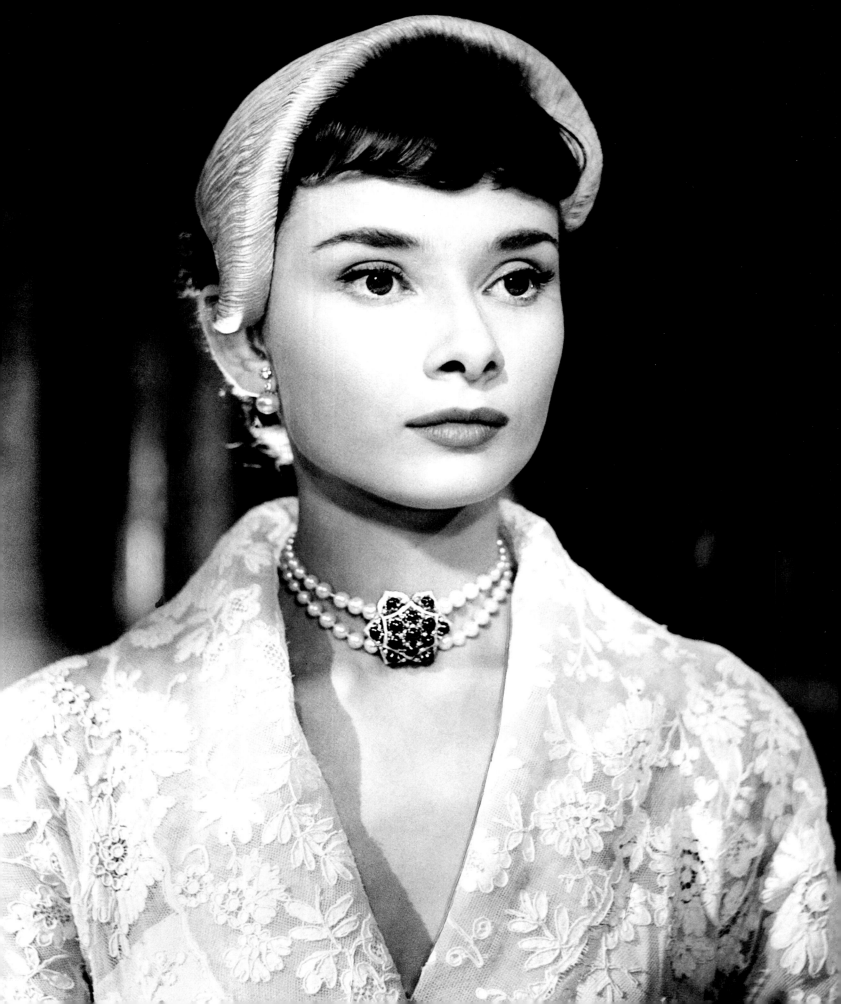

INTRODUCTION

Audrey Hepburn. That marvellous face, those big, magic eyes, her enchanting smile – were made for wearing hats. Throughout her life (1929-93) Audrey Hepburn adored dressing up. On stage, on screen and in her private life she dazzled millions with her unique persona. In this book we focus in close-up on that unforgettable face, in the hats she wore at the height of her movie stardom, photographed by the world's most celebrated photographers.

Winning an Oscar for her first Hollywood movie, *Roman Holiday* (1952), made Hepburn an international star. Audrey captivated movie audiences with her slender physique, perfect posture, graceful movements and 'urchin' face – so different from the reigning sex symbols of the day whose figures were much more of the hourglass kind. Trained as a dancer and fashion model, Hepburn knew exactly what to do in front of the camera. She knew what suited her figure, what parts to emphasize and what to disguise, and she had discovered hats could add an air of mystique, that final accent or exclamation mark to a costume.

The new, fresh and youthful image of Audrey Hepburn as projected in *Roman Holiday* was just the start of many fashion trends she inspired during her career. The short, cropped hairstyle seen in the movie launched a thousand short, look-a-like cuts and was perfectly timed for the fashionably small, close-fitting hats Dior and his New Look preferred.

Like so many accomplished actors, the costumes Audrey wore for film roles were an essential part of realising believable characterisation. Edith Head, who dressed Hepburn for *Roman Holiday*, understood this sentiment and was again to look after Audrey's wardrobe for her next movie, *Sabrina* (1954). However, Hepburn instinctively knew she had to choose her own costumes to perform a convincing transformation from a Cinderella type as the chauffeur's daughter, to a sophisticated woman returning from Paris. Sabrina was to charm and delight both of her father's wealthy employers in this romantic comedy. So Paramount agreed to send Audrey to Paris where she could buy three costumes directly from a Paris couturier.

Meeting Hubert de Givenchy for the first time was embarrassing on two counts. First, Hepburn had originally wanted to buy from Balenciaga but the great couturier had declined, suggesting his good friend Givenchy. Givenchy had recently opened his own couture house in Paris. An appointment was made and Givenchy assumed his new client would be Katharine Hepburn, the established Hollywood star. But when he opened the salon door, before him stood the impish figure of Audrey Hepburn, dressed not in couture but wearing simple black Capri pants, white shirt, flat ballerina pumps and a gondolier's hat.

With embarrassments overcome, the designer was happy for Hepburn to choose three outfits from a rail of sample designs from a previous collection for her role as Sabrina. All the clothes had matching hats. She chose a jazzy grey suit with a white pleated cloche, a little black satin dress with rhinestone cocktail hat and a black and white embroidered ball gown with a velvet headband. Back in Hollywood, Hepburn not only succeeded in charming her co-stars Humphrey Bogart and William Holden but also immortalised the little black dress. After *Sabrina*, Audrey requested Givenchy's clothes for all her films with a contemporary setting. That is how he came to design the outfits she wore in *Funny Face*, *Love in the Afternoon*, *Breakfast at Tiffany's*, *Charade*, *Paris When It Sizzles* and *How to Steal a Million*.

Hepburn's powerful and convincing performance in *Sabrina* won her another Oscar nomination, *Life* magazine's 'Woman of the Year' and a cover profile in *Time* magazine, where director Billy Wilder was quoted as saying, 'Not since Garbo has there been anything like her, with the possible exception of Ingrid

Bergman.' Audrey had also attracted the attention of another celebrated artist and photographer, the well-connected Cecil Beaton, who described her in an article for *Vogue* magazine as, 'A new type of beauty, huge mouth, flat Mongolian features, heavily painted eyes, a coconut coiffure, long nails without varnish, a wonderful lithe figure, a long neck.' Later he would dress her in the role of her life, that of Eliza Doolittle in *My Fair Lady* (1964).

Before setting up his own couture house, Givenchy worked with Paris couturiers Jacques Fath, Lucien Lelong and Elsa Schiaparelli and was a trusted confidant of the great Spanish couturier, Cristóbal Balenciaga. These couturiers were all celebrated as much for their chic hats as their distinctive haute couture. Givenchy was also an accomplished milliner and created many of Audrey's most alluring hats. With Hepburn he chose to accentuate the height and thinness Hollywood might have considered as flaws and that succeeded in retaining a cosmopolitan sophistication that was naturally hers.

Givenchy was one of the most important forerunners of minimalist fashion designs in the 1960s. And Audrey's films played a crucial role in changing fashion sensibilities. Hepburn was enduringly loyal to Givenchy and genuinely adored him. 'His are the only clothes in which I am myself. He is far more than a couturier, he is a creator of personality,' she had said. 'My magic was hers,' said Givenchy, describing their collaboration.

By 1957 when Hepburn appeared in *Funny Face*, a thrilling story of the transformation of a bookstore clerk to modelling sensation, she enjoyed taking part in real life photo sessions in glossy magazines where she got to wear her favourite designer hats and clothes, especially enjoyable if the photographer was Richard Avedon. Fred Astaire played out Avedon's character in the movie.

When Blake Edwards's movie, *Breakfast at Tiffany's* (1961), was still filming, Hepburn was elected to the Fashion Hall of Fame. Every one of her films seemed to launch a trend and *Breakfast at Tiffany's* was no exception. She was 31 when, as Holly Golightly, she wore *that* long black dress in the opening scene, the little black dress with the wide brim hat to visit Sing Sing, the enormously long black cigarette holder, the five-strand pearl necklace and high-top hairstyle. And just about everybody wanted the brown mink hat and orange coat copied. It was not only the clothes audiences fell in love with but also the cat! Pet shops were inundated with requests for ginger cats just like the stray in the movie.

There was an element of fun and fantasy to hat design in the 1960s and despite the fashion for bouffant hairstyles and the frequent use of wigs as a fashion item, hairdressers did not succeed in taking over the dressing of heads. Audrey continued to wear the new sculptural hats that Givenchy made for her screen and private wardrobes. Hepburn and Jacqueline Kennedy frequently wore the pillbox, perched neatly on the back of the head. Over-scale toques were glamorous in fur or felt and model hats made by the top Paris designers were moulded into space-age helmet and dome shapes. The large, romantic picture hats, Breton and coolie hats in textured straw suited Audrey as much as the more formal designs. It seemed that despite changing attitudes, a finished, all-over fashion look could still not be achieved without a hat.

The origins of many contemporary hat designs derive from religion and the military, from the cardinal's biretta, Tibetan monk hat, Dervish dancers and Jewish skull caps; the beret, helmet and peaked cap to name a few. Locks of St. James Street, Mayfair, are famed as the creator of the bowler hat. Oriental fantasy was played out dramatically with Paul Poiret's turban towards the end of the belle époque era and has remained fashionable ever since. Venetian gondoliers, who tied brightly coloured ribbons around the crowns of their

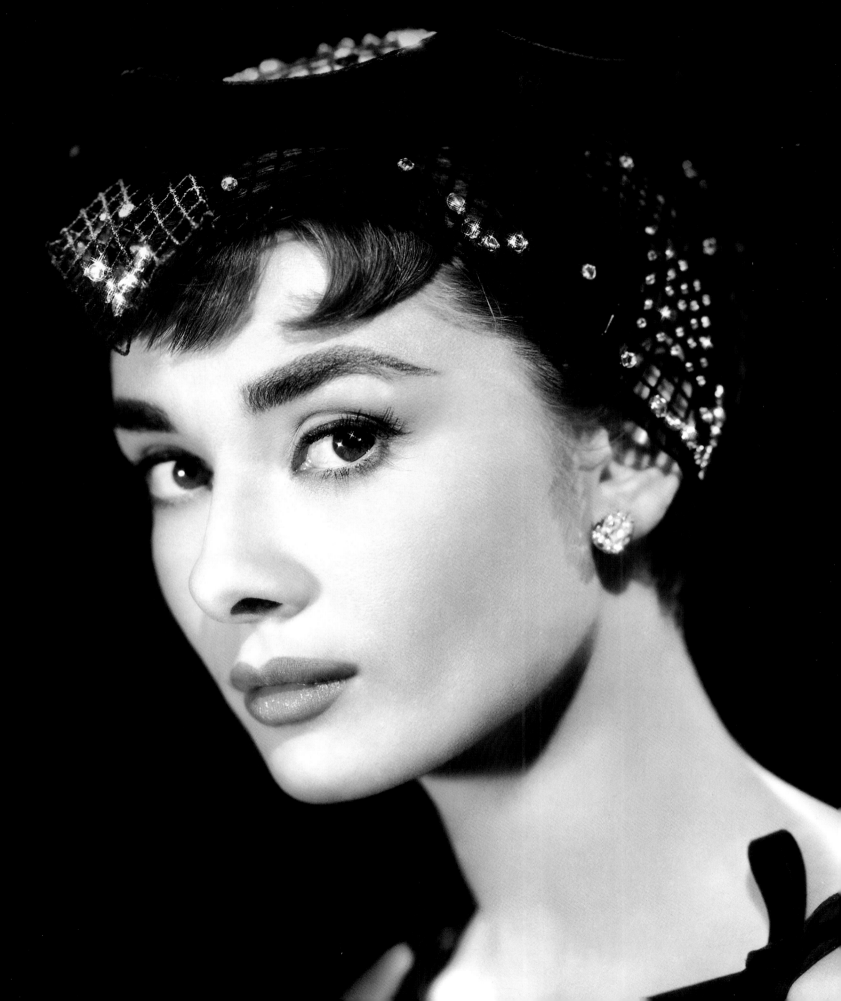

flat top hats, were probably the inspiration for the boater and a Philadelphia hatter named John B. Stetson affectionately called his Stetson hat Boss of the Plains. It was a particular hit out West, where the cowboy era was in full swing.

During the 1950s and 1960s a number of milliners produced outstanding hats and were in great demand by the fashionable women of the day. **Paulette** worked with all the great Paris couturiers from the 1950s to the 1980s. Her hats were always in tune with the mood of the moment, she was famous for her turbans, sculptural in form with all unnecessary decoration stripped away. **Balenciaga** – the only thing that mattered to him was his metier. He tended to make his hats very large or very small in contrast to the scale of the outfit and his creations were surprisingly witty for a very serious man. **Dior**'s millinery was created by **Maud Roser** but the couturier himself made the final choice of which hat went with an ensemble. He understood hats very well having once sold them for the milliner **Agnes**.

New York was the home of many talented milliners at this time. **Lilly Daché** was as glamorous as her clients and was much sought after by society women who wanted to make a positive statement. Her hats were best described as dramatically controlled. **Hattie Carnegie**'s hats bore the label 'Hatnegie' and were sold coast to coast in top quality stores. **Mr. John**, as well as being New York's pre-eminent milliner, was brilliantly entertaining and adored by his customers, even though his outrageous behaviour could be eccentric. Once in the 1960s he created a turban for a client and when he handed her the bill for $100 she told him the price was outrageous. He then unravelled the turban and said, 'Madam, the materials are free.' He set up his own business in the 1950s and every Hollywood star walked through his lavish showroom doors. He designed some of the most romantic hats of this century – for Scarlett O'Hara in the film *Gone with the Wind* – and **Cecil Beaton** consulted him when designing the fabulously extravagant hats and costumes for *My Fair Lady*. **Halston** was appointed Jacqueline Kennedy's milliner throughout her reign as America's First Lady. He made the pillbox a little larger to accommodate her hairstyle and it became every stylish woman's must-have in the mid-1960s. **Sally Victor** was the milliner instrumental in making fine hats available to the vast numbers of middle-class American women and her firm became the biggest millinery company in the United States.

Aage Thaarup was born in Denmark at the beginning of the twentieth century. He opened his millinery business in London in the early 1930s and soon became one of the charmed circle of suppliers to the Royal Family. His beautifully executed and delightfully whimsical hats were often worn by the Queen Mother and the young Queen Elizabeth II. **Simone Mirman** was a Frenchwoman who trained with the legendary milliner, **Rose Valois**, and worked in **Schiaparelli**'s London branch in the 1930s before opening her own establishment in London in 1947. She too began designing hats for royalty. First for the Princess Margaret in 1952, then the Queen Mother and Queen Elizabeth. **Frederick Fox** is another of the Royals' favourites, a most charming and cultured man who often designed hats to go with the Queen's Hardy Amies and Norman Hartnell costumes. **James Wedge** and **Graham Smith** were the hip young London milliners of their time during the Swinging Sixties.

It is clear for all to see that Audrey Hepburn loved wearing hats of all shapes and forms. She remained the epitome of understated chic throughout her screen life, always looking immaculately well groomed, even when relaxing at home or seen as a representative for Unicef in the Ethiopian desert. Women of all ages from different backgrounds still look at her for her style and her grace and see it as something they want to emulate.

JUNE MARSH

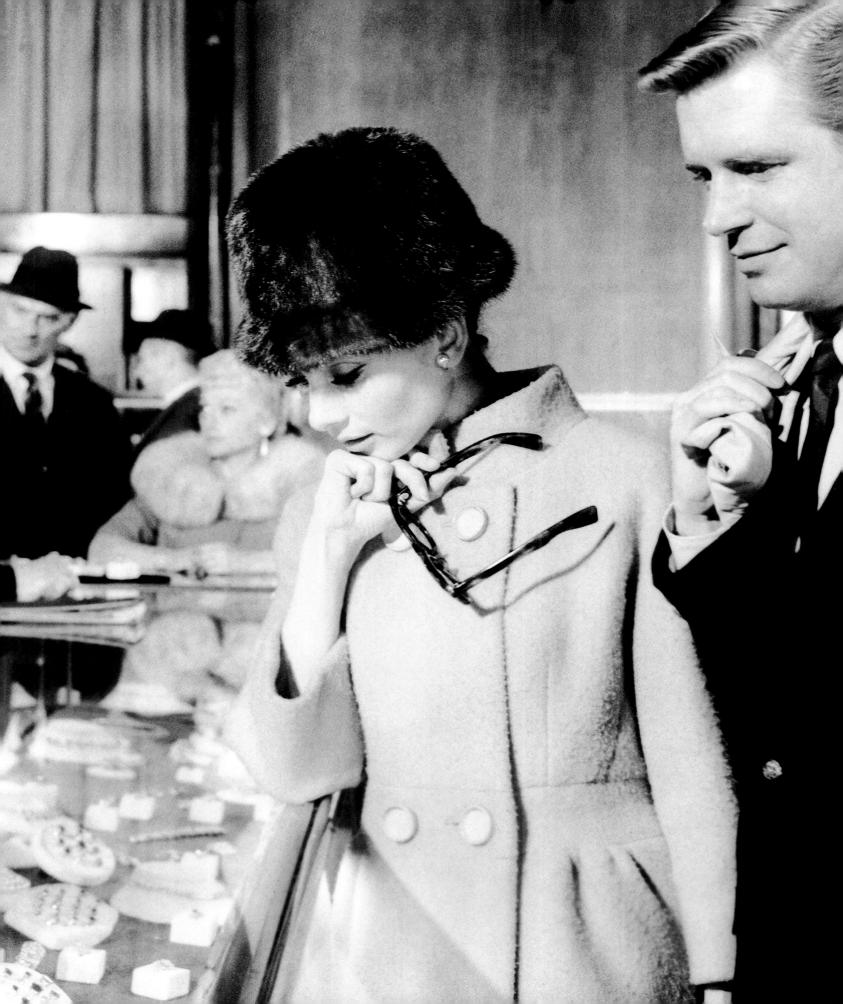

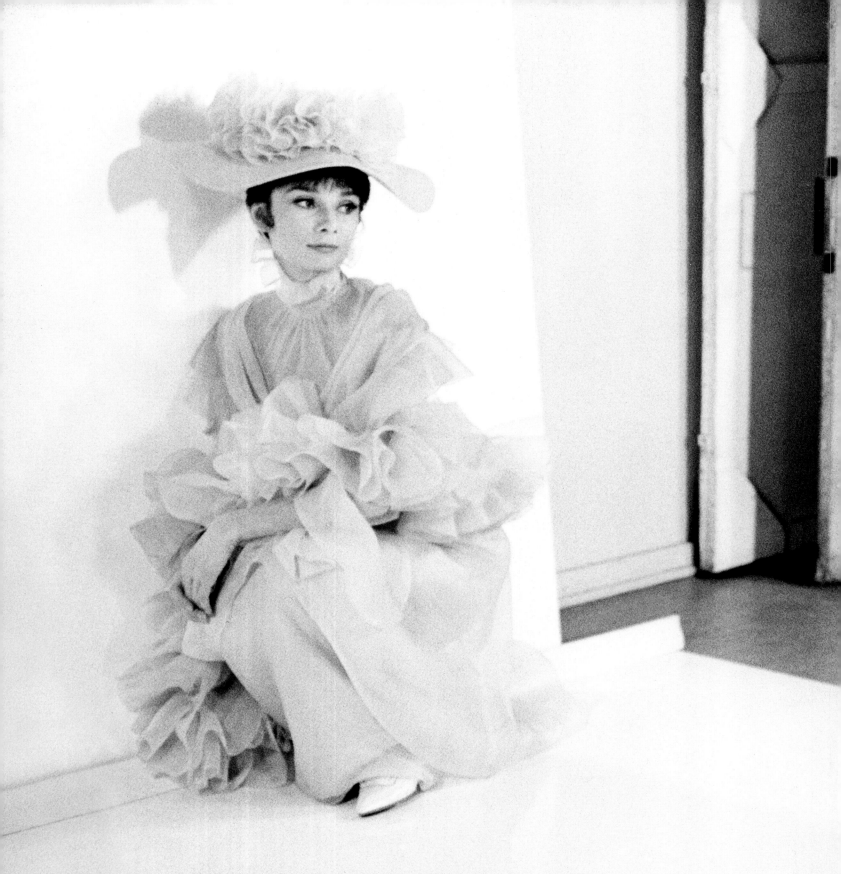

AUDREY HEPBURN IN HATS

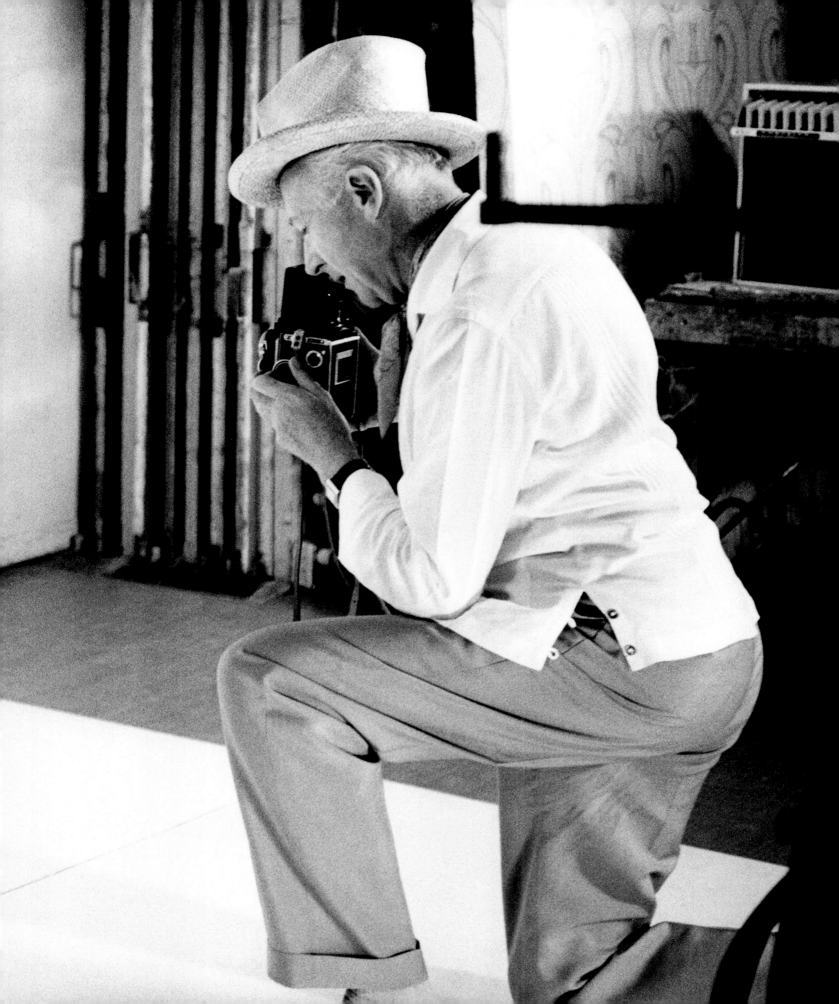

A youthful Audrey looks the part seated
at the helm of a sailboat in a classic linen yachting cap
with black leather peak and gold anchor insignia.
She often wore a bandana around the neck
she thought too long.

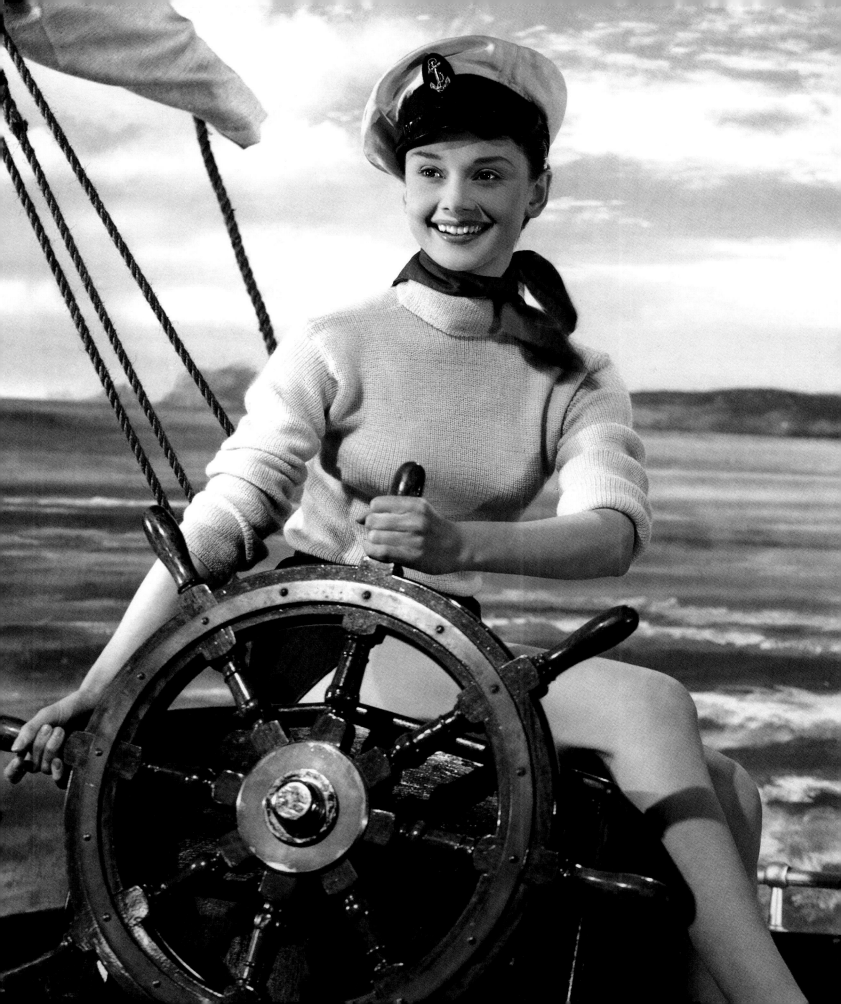

A 1960s textured straw hat is reminiscent of a
Victorian bonnet the way Audrey has drawn it in under her
chin with ribbon. Straw hats were originally worn
in the country by working women in the seventeenth century
until more intricately worked straw was imported from
Italy for aristocratic use in England.

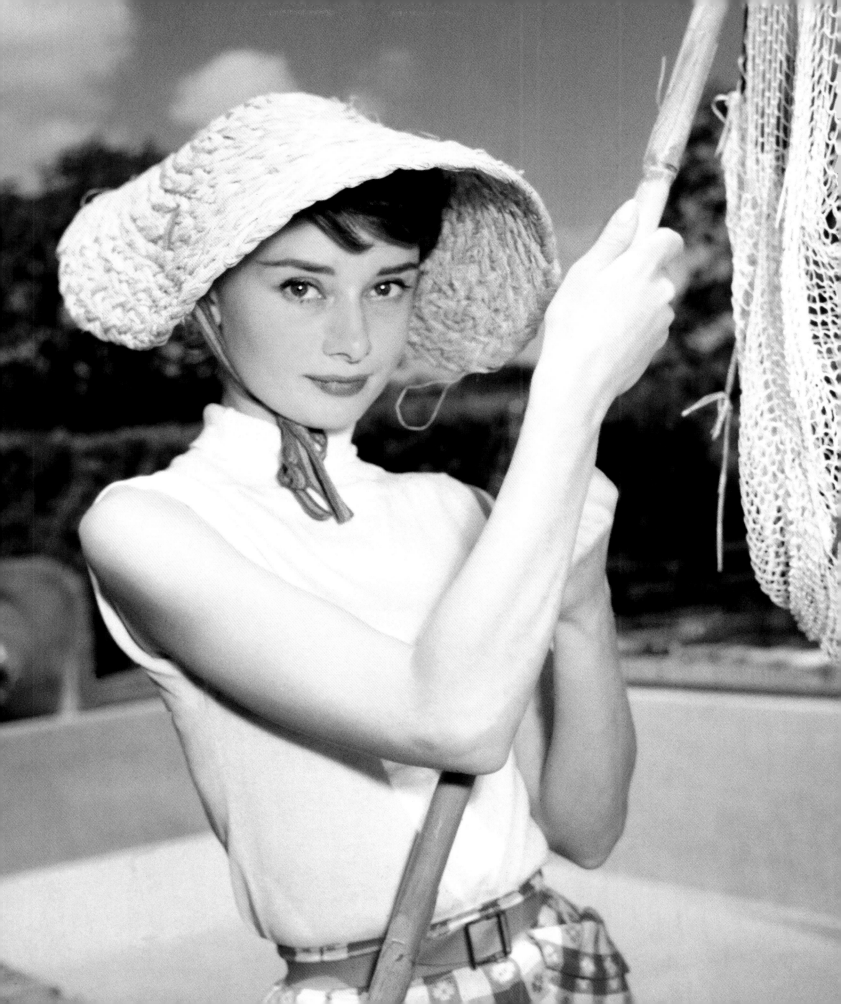

A sassy white pleated cloche was another
of the chic choices Audrey made when given the
freedom to choose her own costumes from Givenchy in Paris.
Sabrina, her second and iconic Hollywood movie, made her
an international star and fashion trendsetter.
Photograph by Dennis Stock

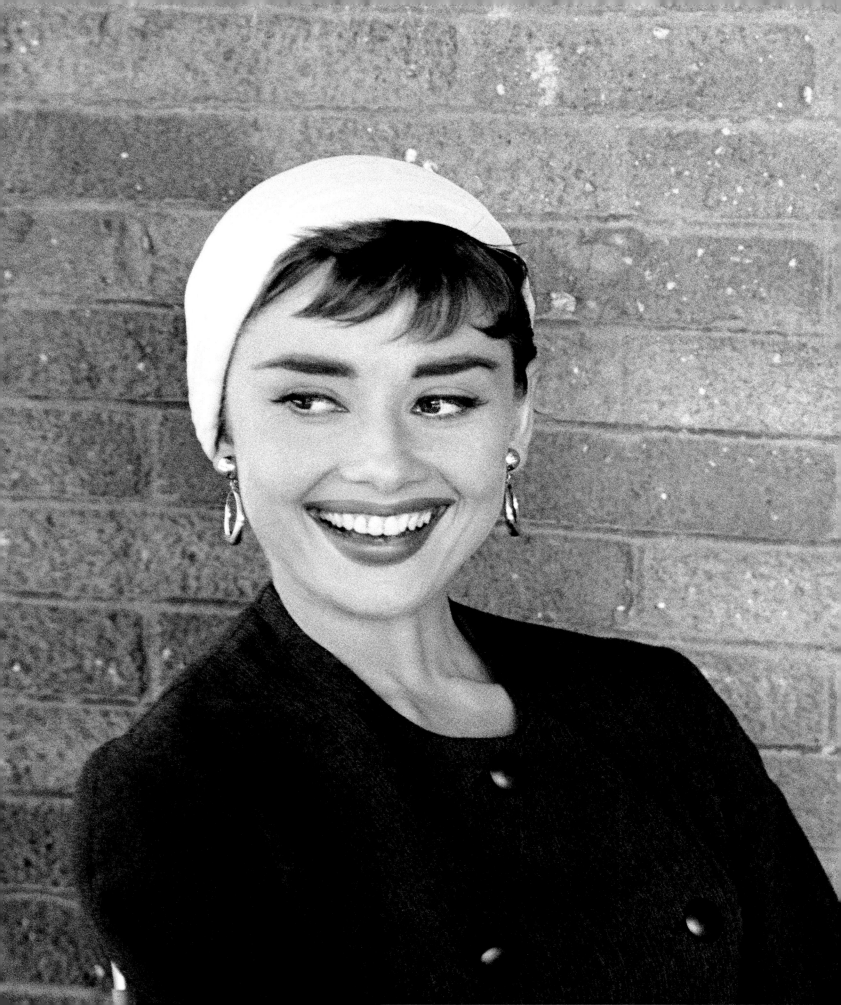

An elegant brown velvet hat designed by
Givenchy – one of the many couture costumes Audrey
wore as Jo Stockton in *Funny Face*. Her Yorkie,
Famous, shares the limelight snuggled up to
her in the fur wrap over her arm.
Photograph by Bert Hardy

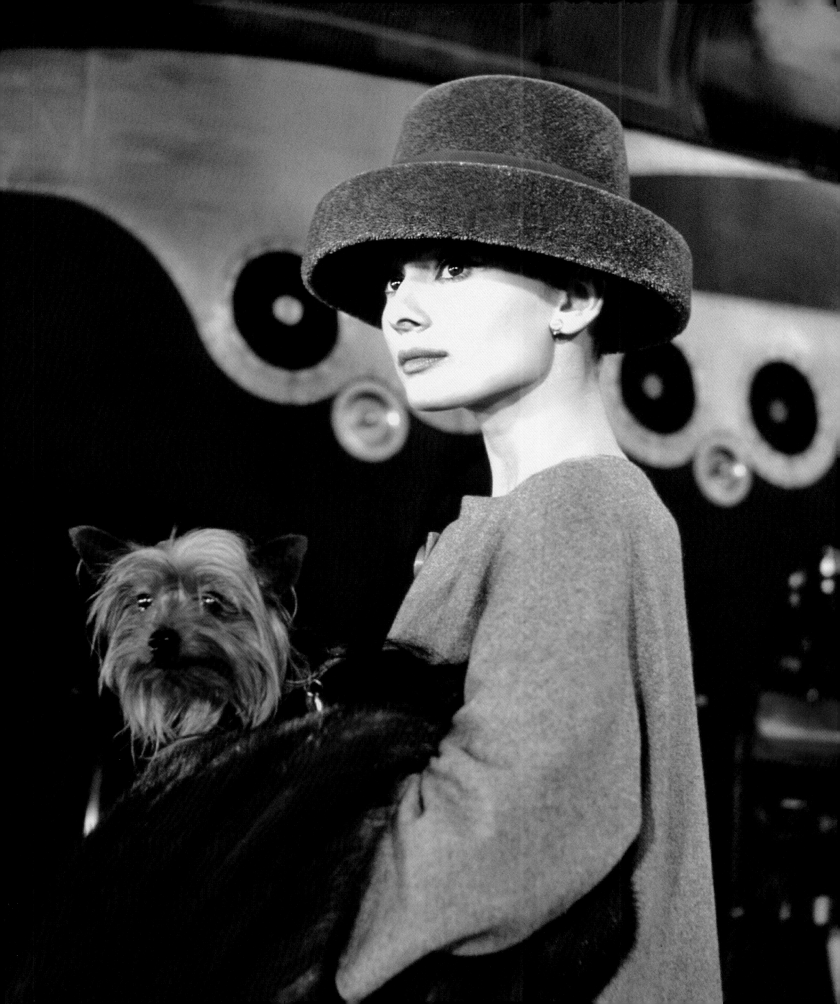

A whimsical, steeple-crown straw hat with
a narrow curled brim and wide ribbon trim, reminds
one of the American gentleman's derby of the late
nineteenth century. The shape is cleverly designed to draw
attention to Audrey's wide, expressive eyes.
Photograph by Bud Fraker

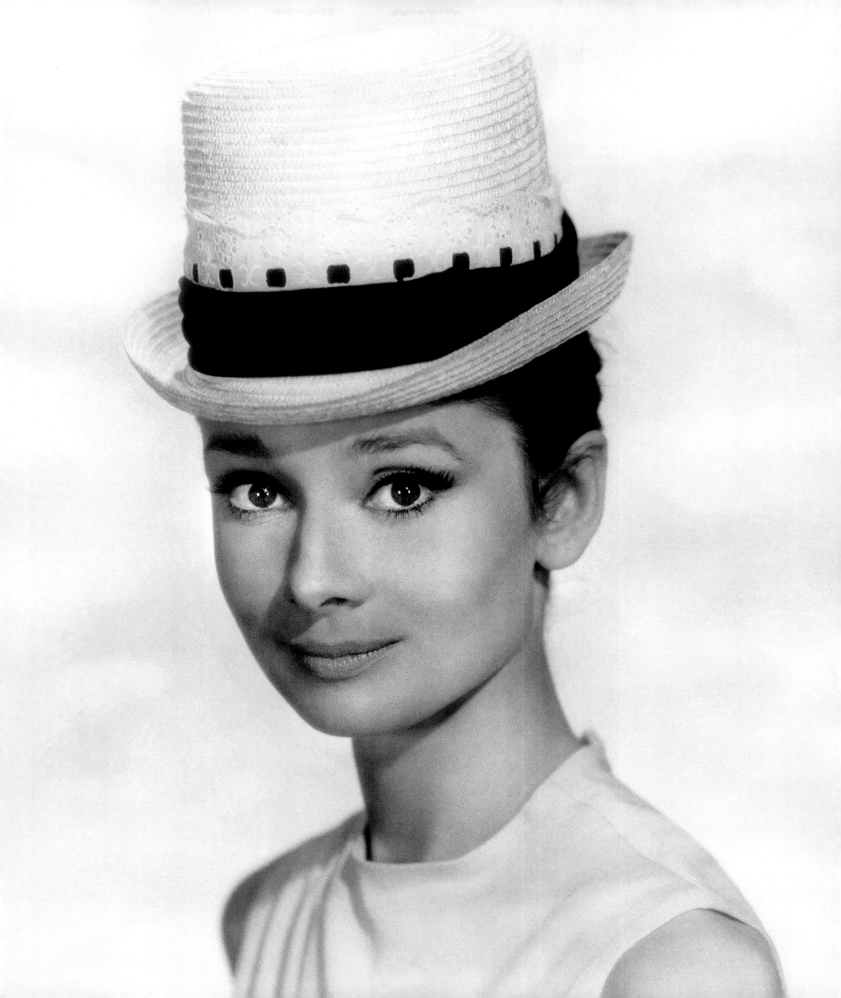

A fine straw hat that perfectly suits the
boat neck tunic Audrey wore in the fishing scene on the
Seine in *Funny Face*. Givenchy added two pink bows to
emphasize Hepburn's high fashion status as star model
in the film's fictional *Quality* magazine.
Photograph by Bud Fraker

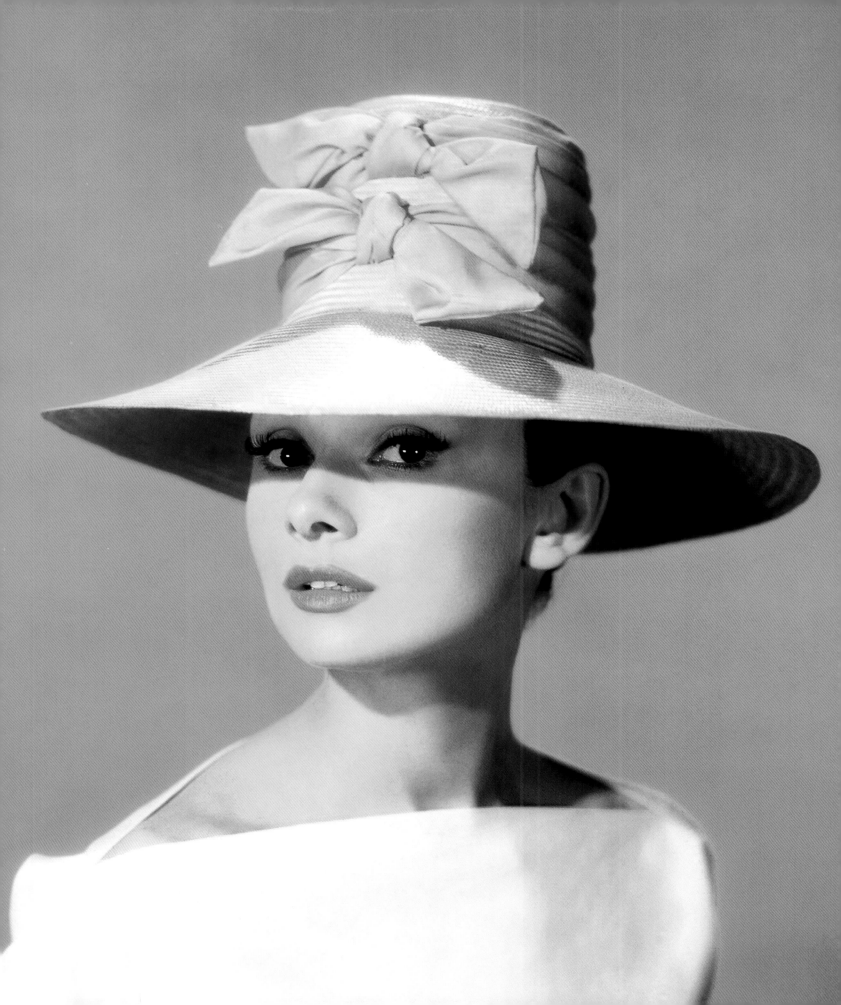

Givenchy designed most of the hats
Audrey Hepburn wore. This interesting straw hat created
for a scene in *Funny Face* has a wide crown and
turned down brim with a stripe ribbon band. It is again
carefully proportioned to avoid covering her eyes.
Photograph by Bud Fraker

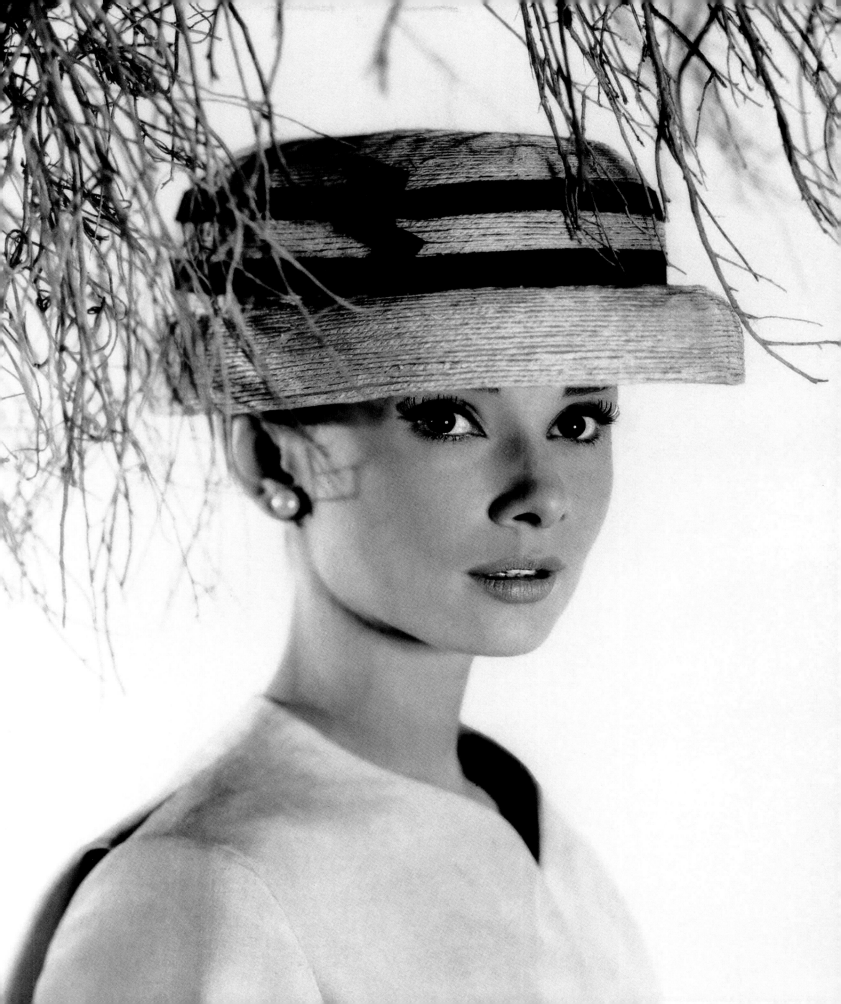

Audrey Hepburn often chose to wear a hat
for publicity shots, magazine covers or just for fun.
This 1960s woven straw design is a combination of
a fez and a bowler hat with a high crown, narrow
curled brim, tassel and ribbon trim.
Photograph by Bud Fraker

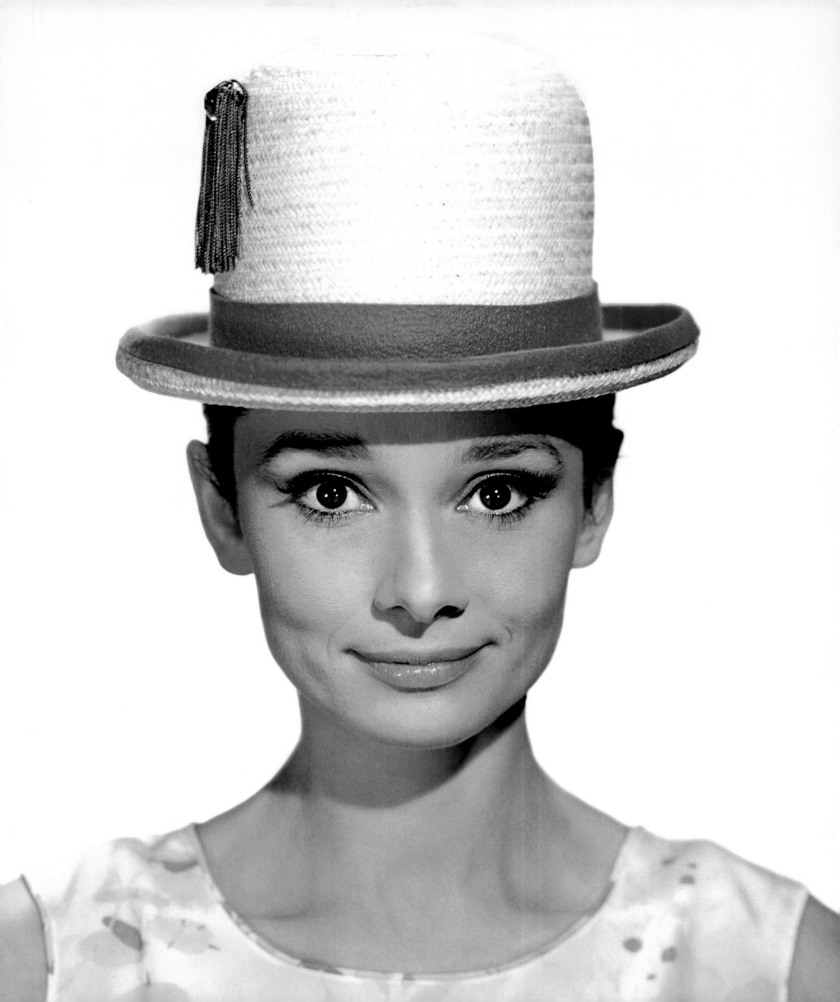

The perfect model. Audrey in one of the
exquisite couture hats Givenchy created for her
as Jo Stockton in *Funny Face*. The height
and simplicity of the design, a classic shape similar to
the Turkish *Kepi*, highlights her translucent beauty.
Photograph by Bud Fraker

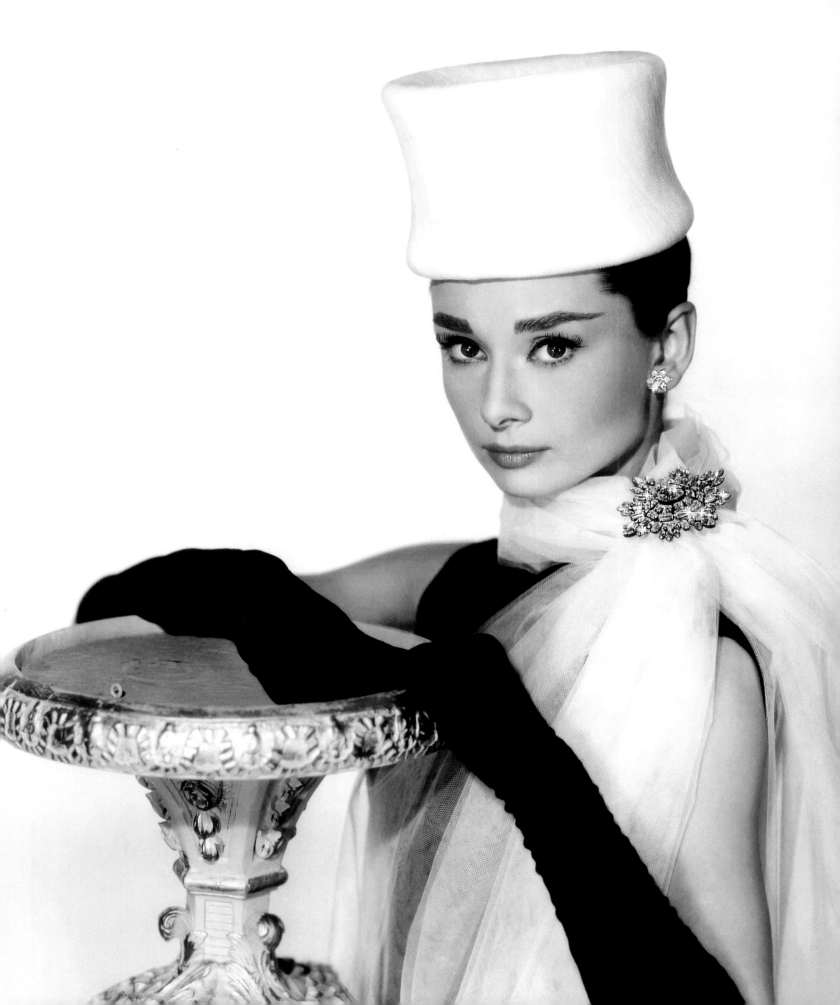

As aptly named Nicole Bonnet in *How to Steal a Million*, Hepburn once more finds herself on location in Paris, in the 1960s, wearing a variety of great designs by Givenchy. This white felt style was a popular 1960s design and looked great on Audrey.
Photograph by Bud Fraker

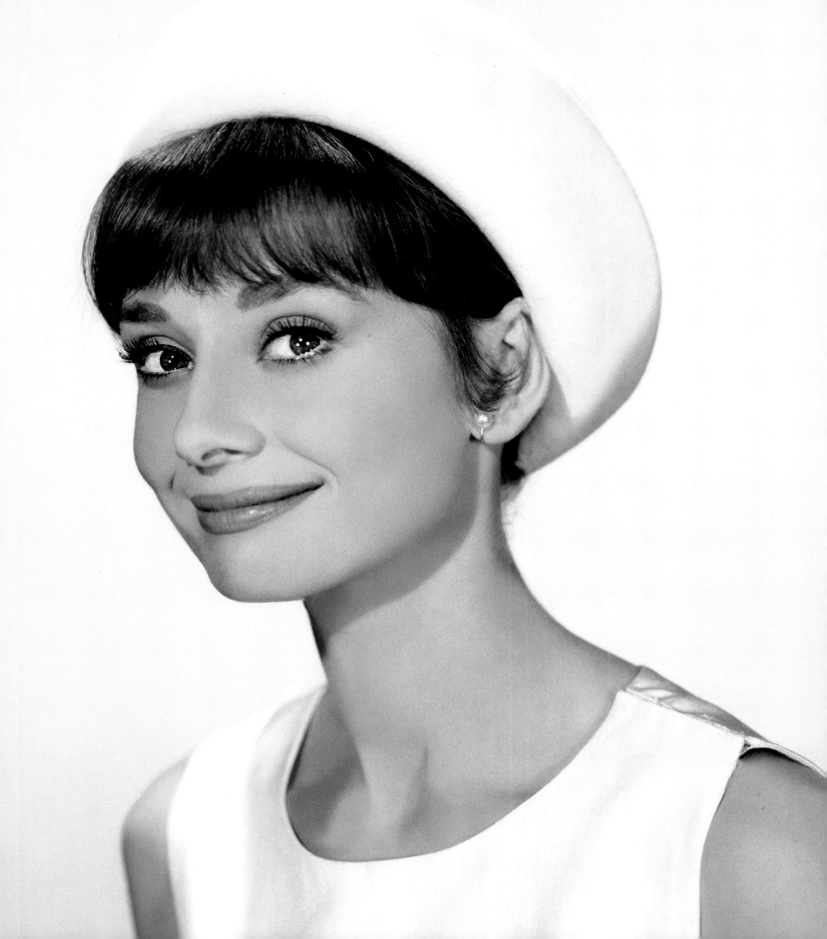

A wonderful look of calmness and confidence
is clear to see when Audrey Hepburn is happy with what
she is wearing. This attractive green silk hat in the shape
of a beret, worn tilted on the back of her head,
is made from delicate silk flower petals.
Photograph by Bud Fraker

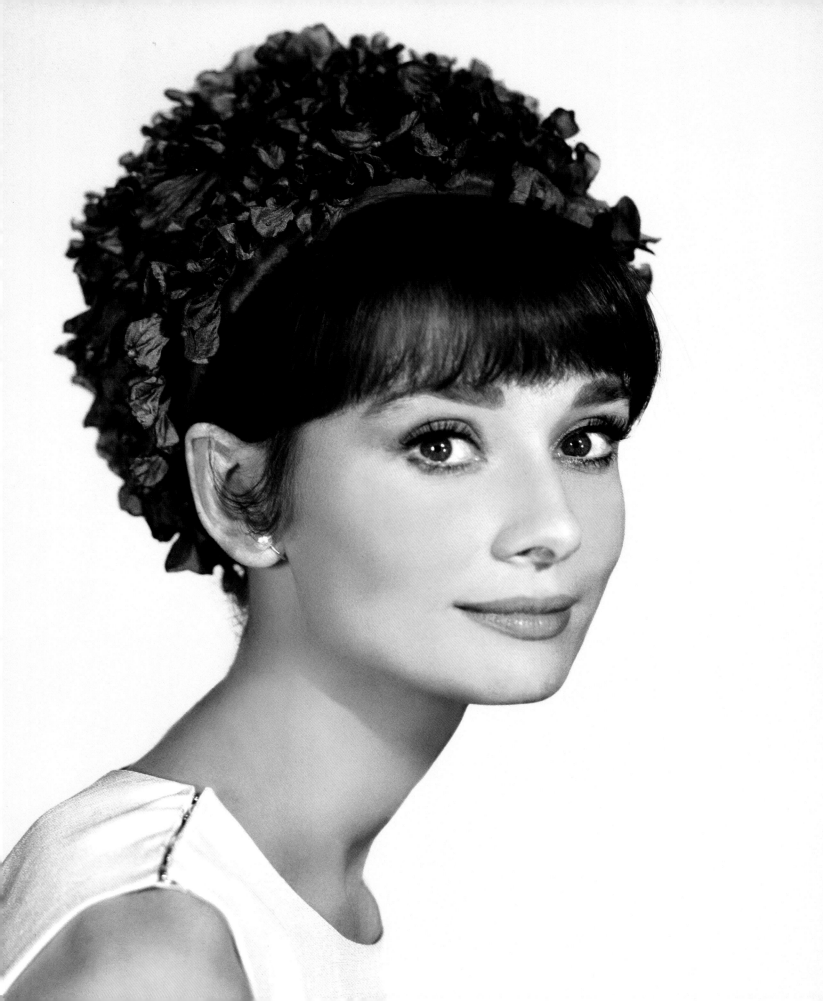

Timelessly elegant, a wide brim hat
acts to frame, as well as give an air of mystery to
Holly Golightly's regular visits to mafia boss Sally Tomato
in Sing Sing in *Breakfast at Tiffany's*, which remains one
of Hepburn's most memorable films.
Photograph by Bud Fraker

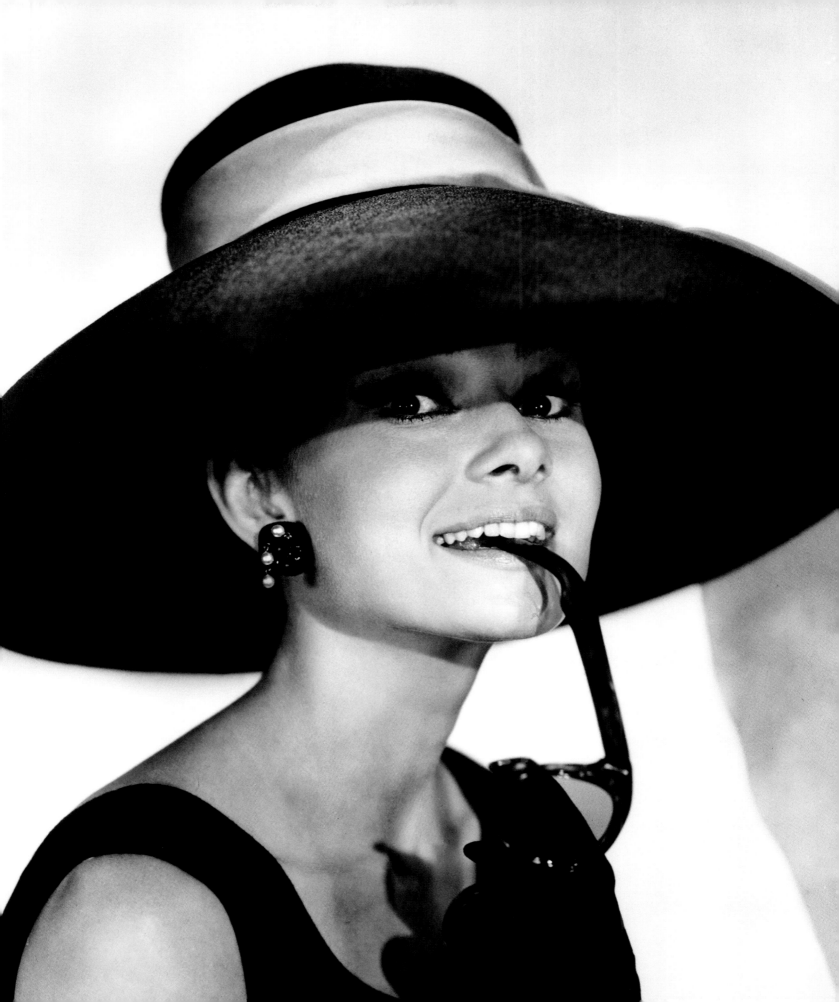

This strikingly chic, black velvet toque hat
embellished with a white down and black feather pom pom
not only starred in *Breakfast at Tiffany's* but also appeared on
the cover of French *Elle* magazine on 8 January 1962.
Photograph by Bud Fraker

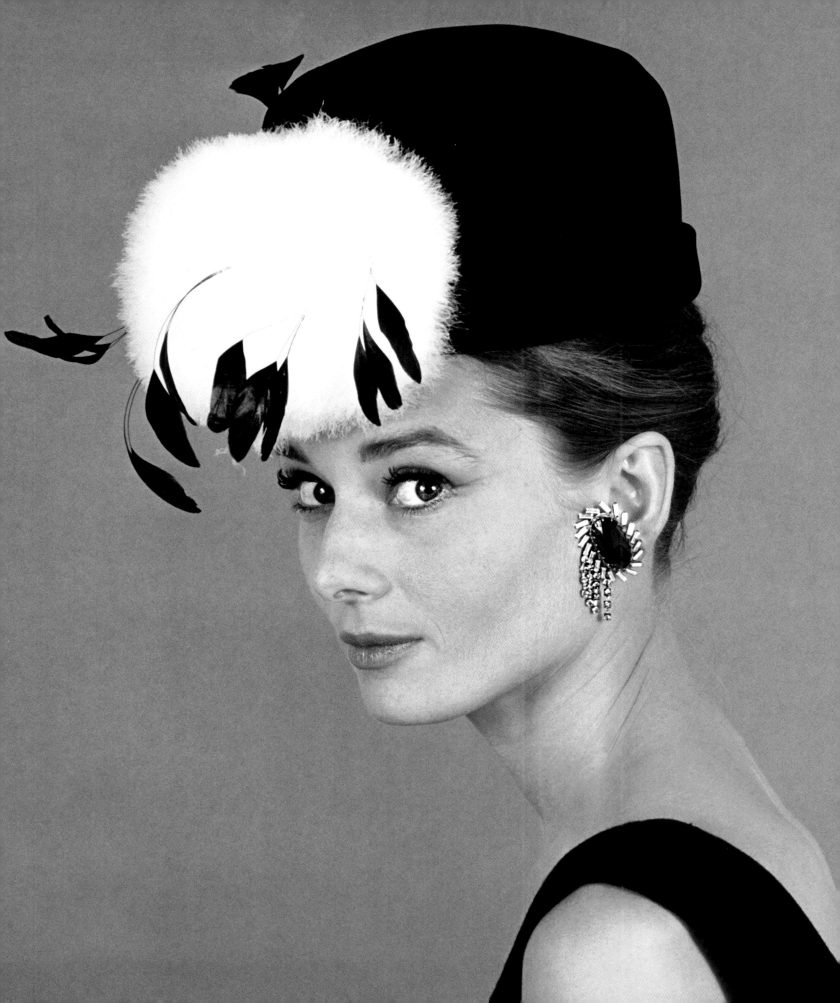

Audrey was always happy to pose in Hubert
de Givenchy's new collections. He became famous for his
minimalist suits, coats and dresses. Set against a rustic
wooden wall, this navy blue 1960s ensemble is accented
by a beautiful lacquered straw hat, its wide brim fashioned
into a gentle curve and trimmed with a neat bow.
Photograph by Howell Conant

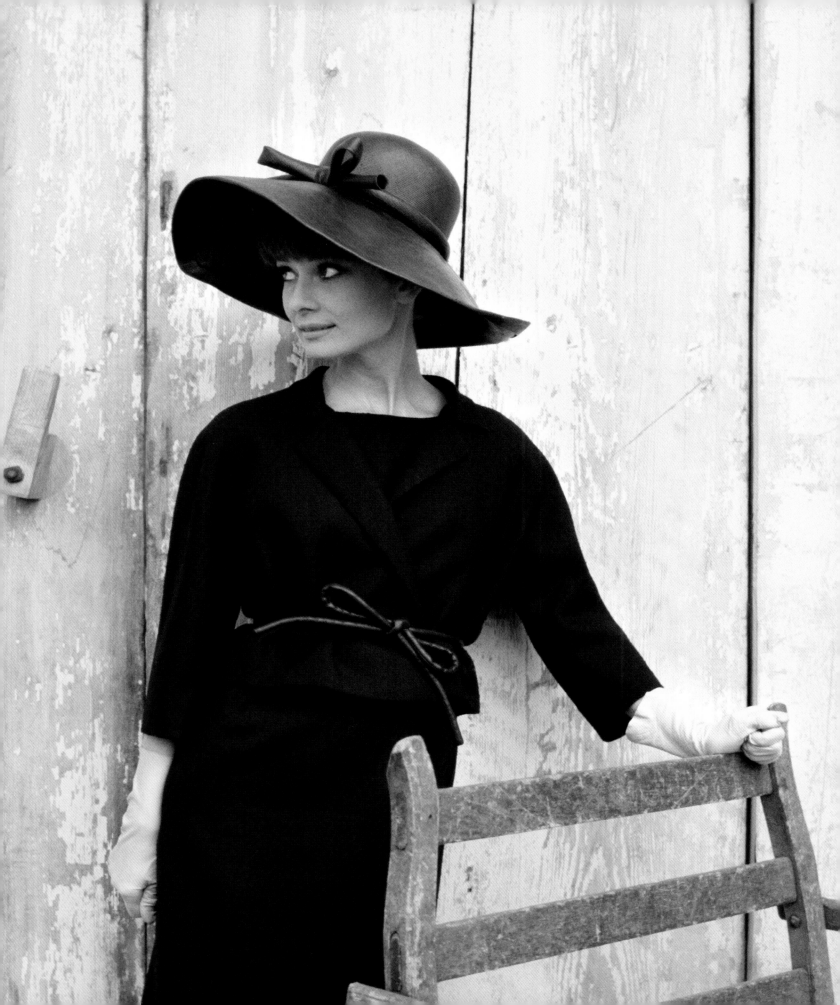

Posed against the rich dark carvings of
Audrey Hepburn's chalet in Gstaad is Givenchy's rose
pink Panama straw pillbox, set characteristically
at the back of her head and featuring the extra
dimension of an upturned shallow brim.
Photograph by Howell Conant

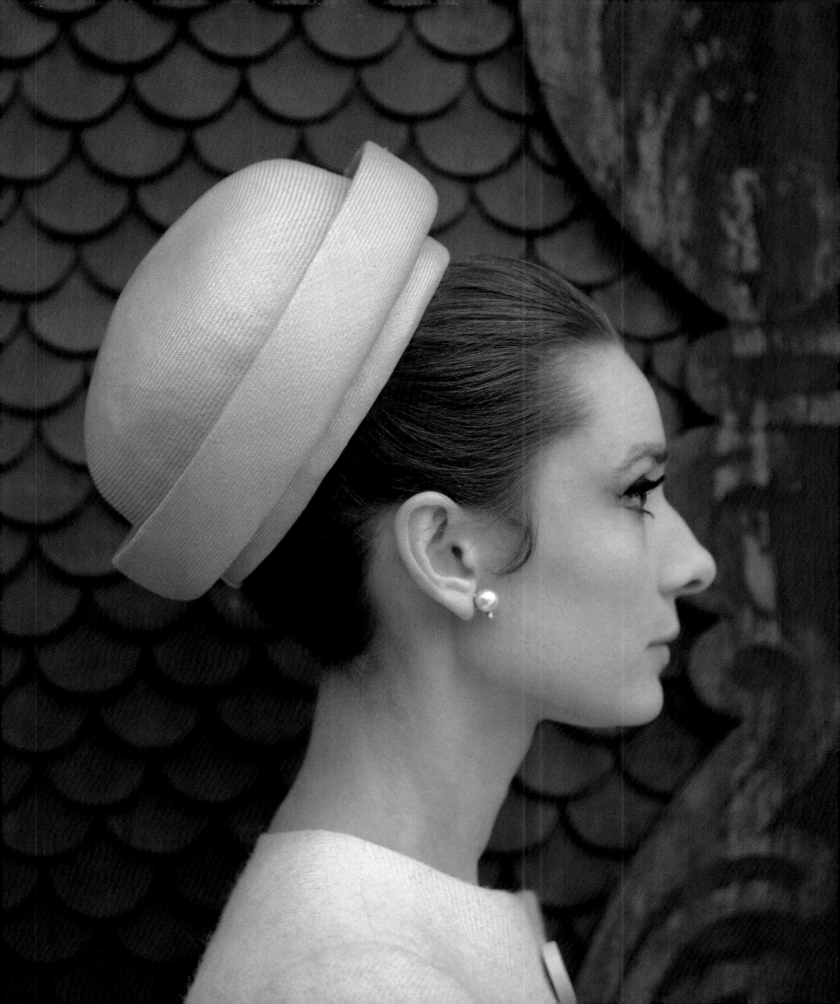

A Cavalier-style straw hat, made from
vegetable fibre, worn casually by Audrey Hepburn for
a studio publicity shot in the 1950s. It is a classic
shape originally worn by Spanish horsemen in the
seventeenth century, made fashionable by the Flemish
painter Sir Anthony van Dyck and which became part of
fashionable dress in the American colonies.
Photograph by Howell Conant

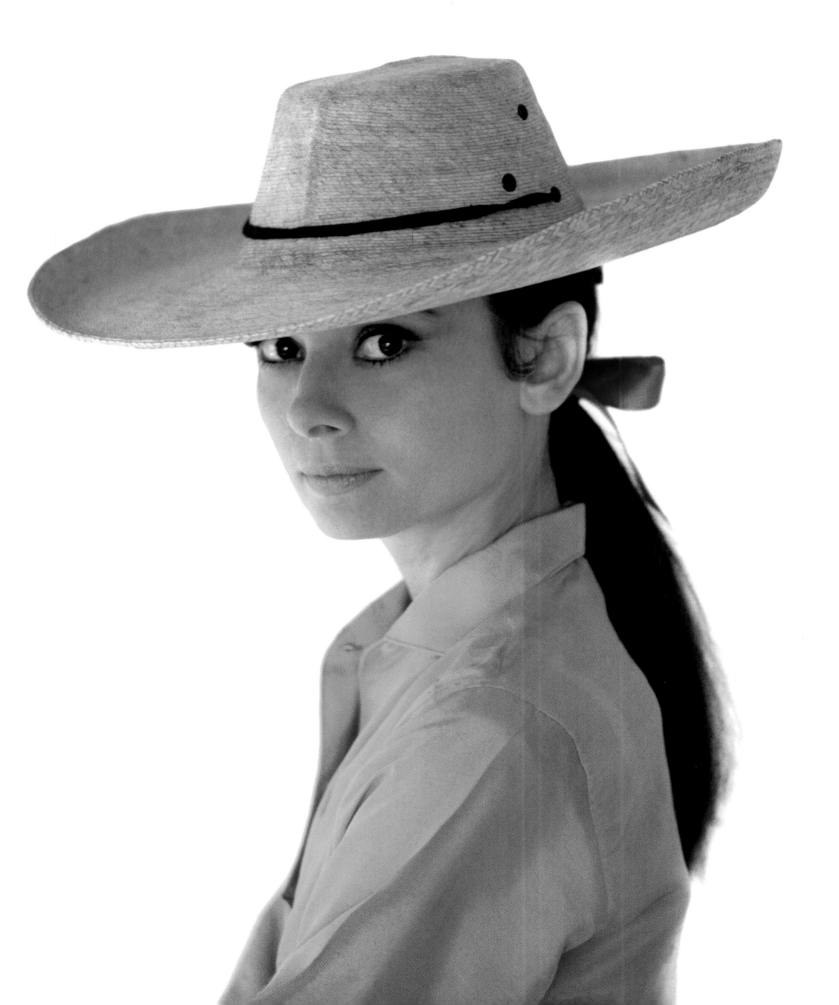

In this mid-1960s photograph, Audrey is
wearing a cocktail hat based on a giant blue daisy covered
in pearls and rhinestones, which gives her
a fresh, youthful look.
Photograph by Howell Conant

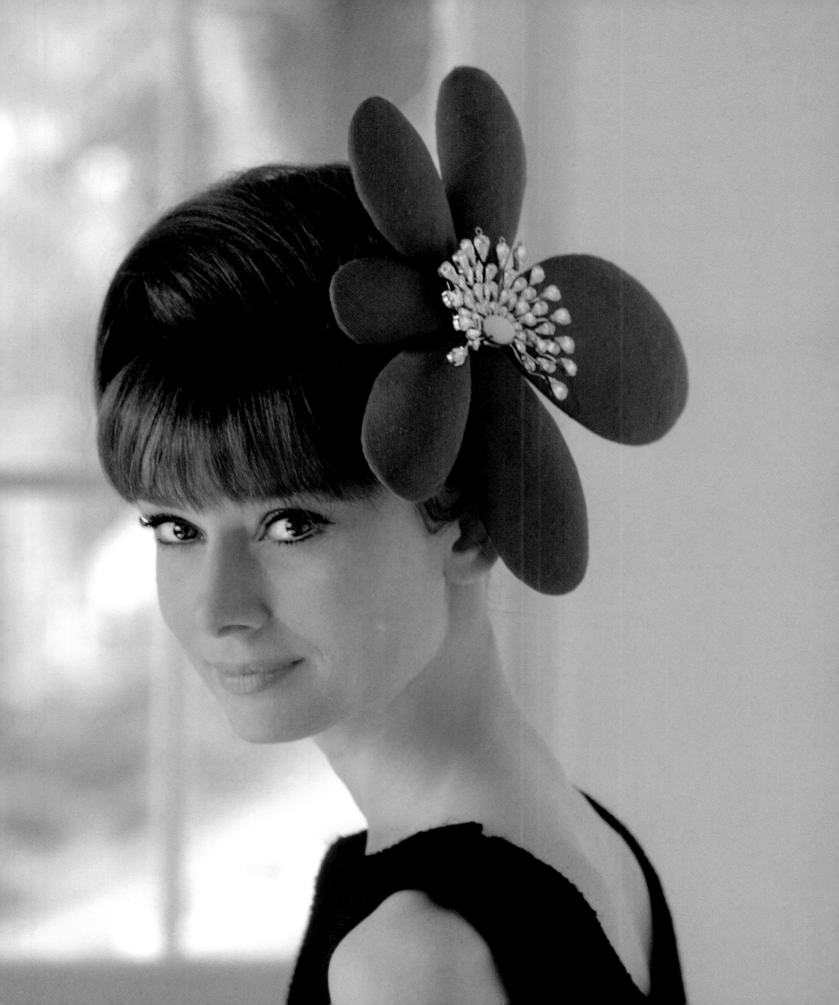

In a 'Lady of the Manor' style, Audrey is
seen here posing against a *trompe l'oeil* background
in another of Givenchy's mid-1960s neat spring suits
and a trilby-style lacquered straw hat.
Photograph by Howell Conant

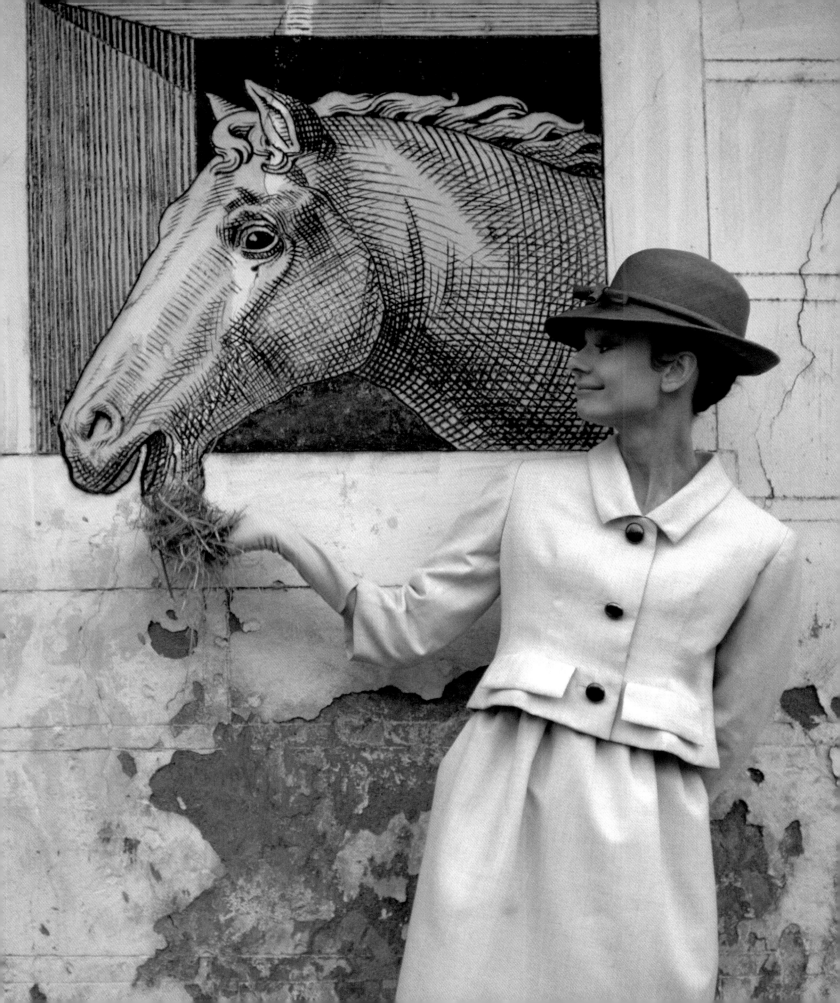

Framing Audrey's flawless face, a dramatic pale
blue pillbox hat features a cascade of delicate feathers
falling towards her face. The photograph originally
appeared on the cover of *Life* magazine in 1962. Hats were
very much in competition with elaborate up-styles
and bouffant hairdos in the 1960s.
Photograph by Howell Conant

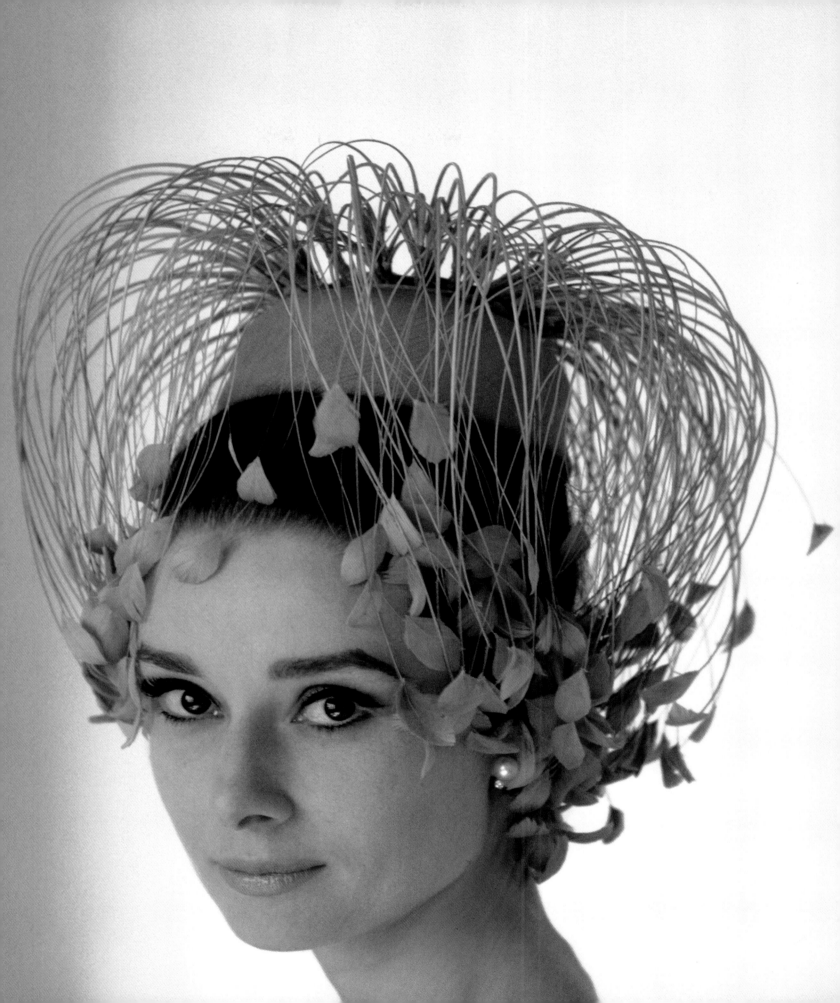

There are so many expressions marking the
importance of the hat. Audrey knew hats conferred a
sense of presence and poise that could not be achieved
through clothing or other accessories. This hat shows an
example of the sculptural qualities of millinery.
Photograph by Howell Conant

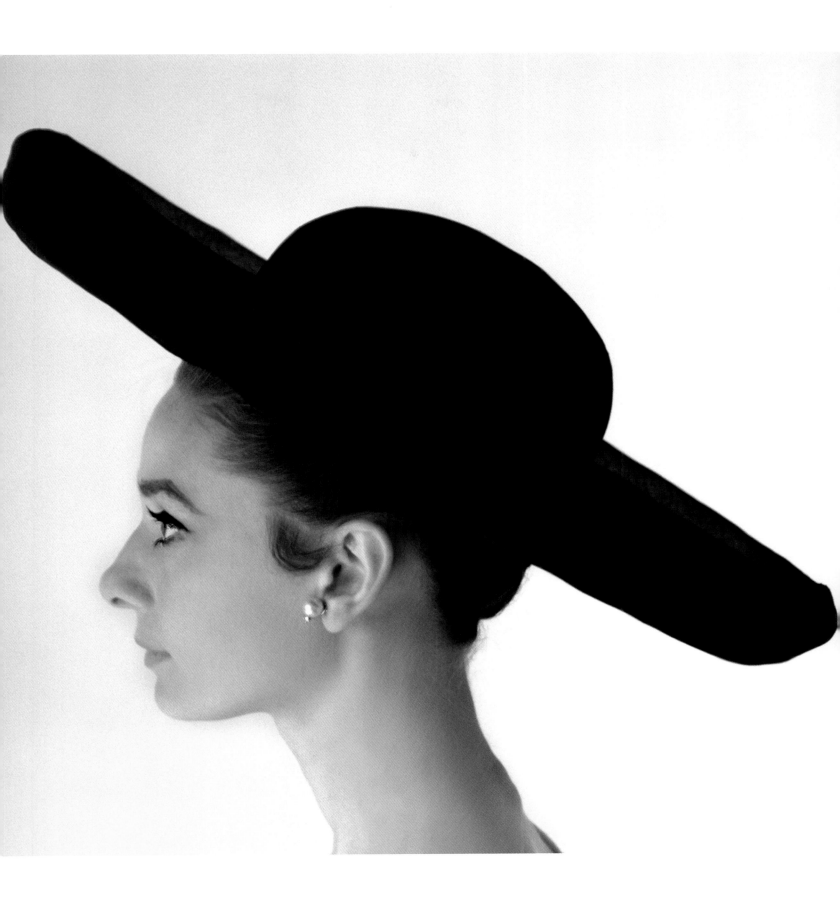

Even the most outlandish futuristic hats,
like this one imitating the petals of an exotic flower
or perhaps the feathers of a regal swan,
looked stunning on Audrey Hepburn's pretty head.
Photograph by Howell Conant

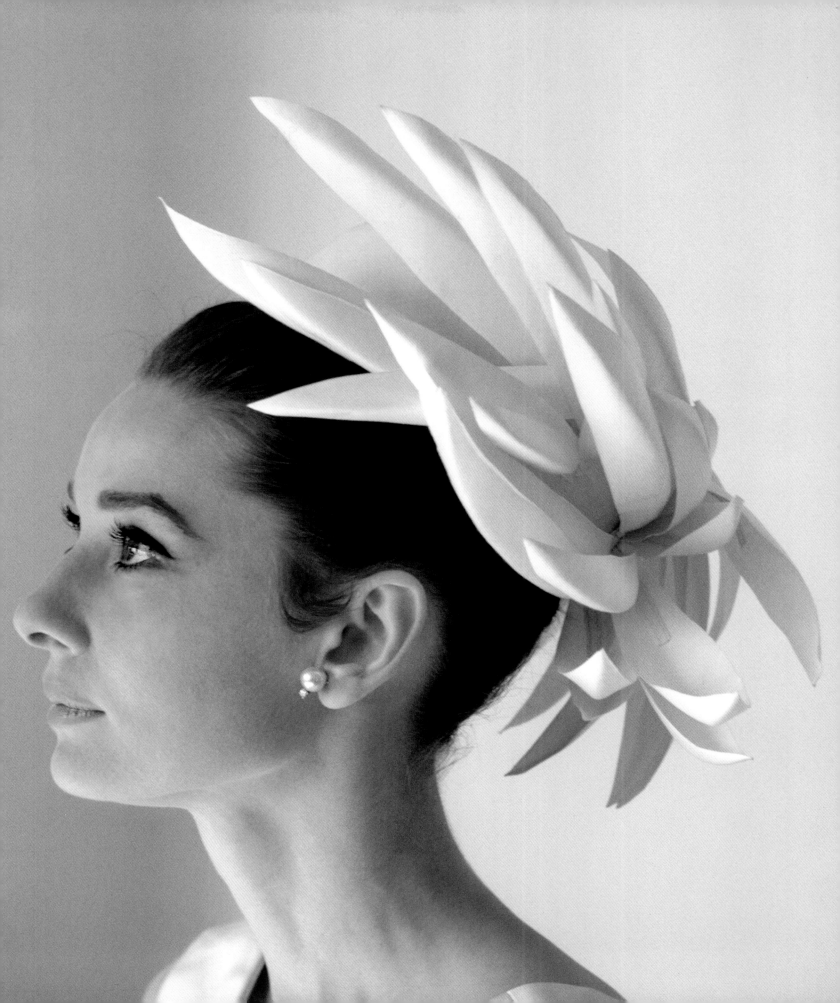

Audrey looked comfortable and relaxed in hats.
This winter variant of the pillbox, photographed in 1961,
was made from black and white fur. Rumour
had it that Audrey became a style model for Jackie Kennedy
when she became America's First Lady in 1962.
And although she did not like wearing hats, the
pillbox became Jackie's signature hat throughout her
husband's presidency.
Photograph by Howell Conant

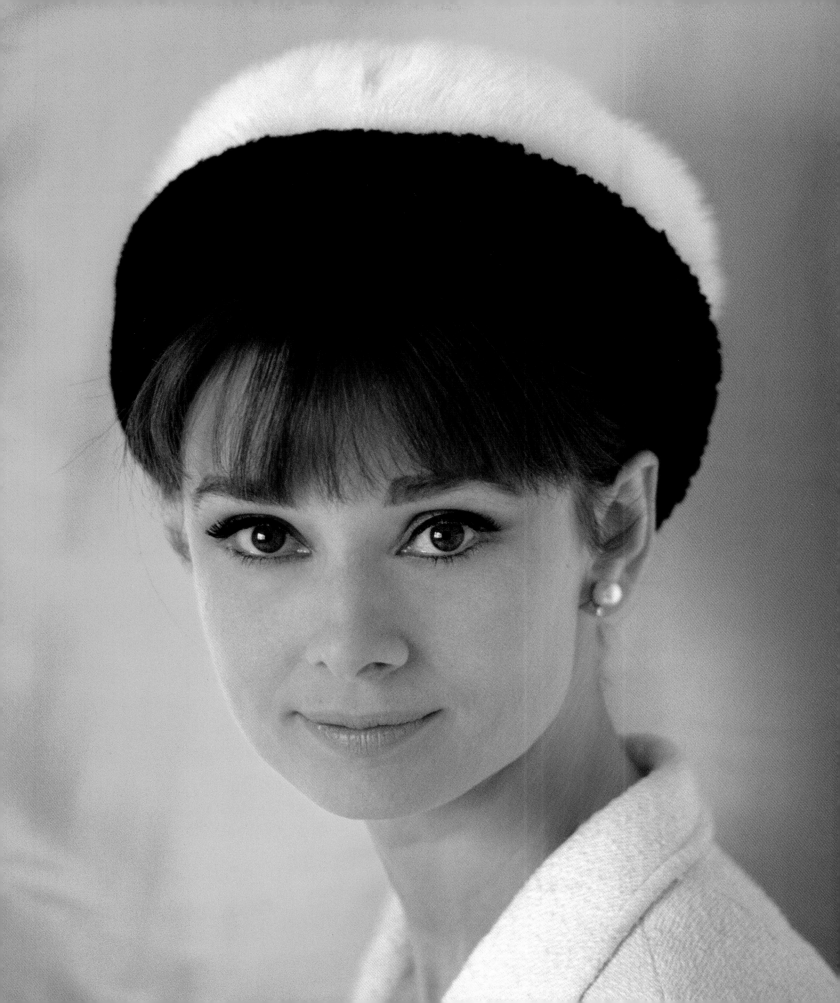

Many contemporary hat styles derive from
the military. In this unusual photograph, Audrey is dressed
in a traditional Scottish cap. The Glengarry
hat is a boat shaped cap without a peak, made of
thick woollen material with a toorie or bobble on top and
ribbons hanging down behind.
Photograph by Howell Conant

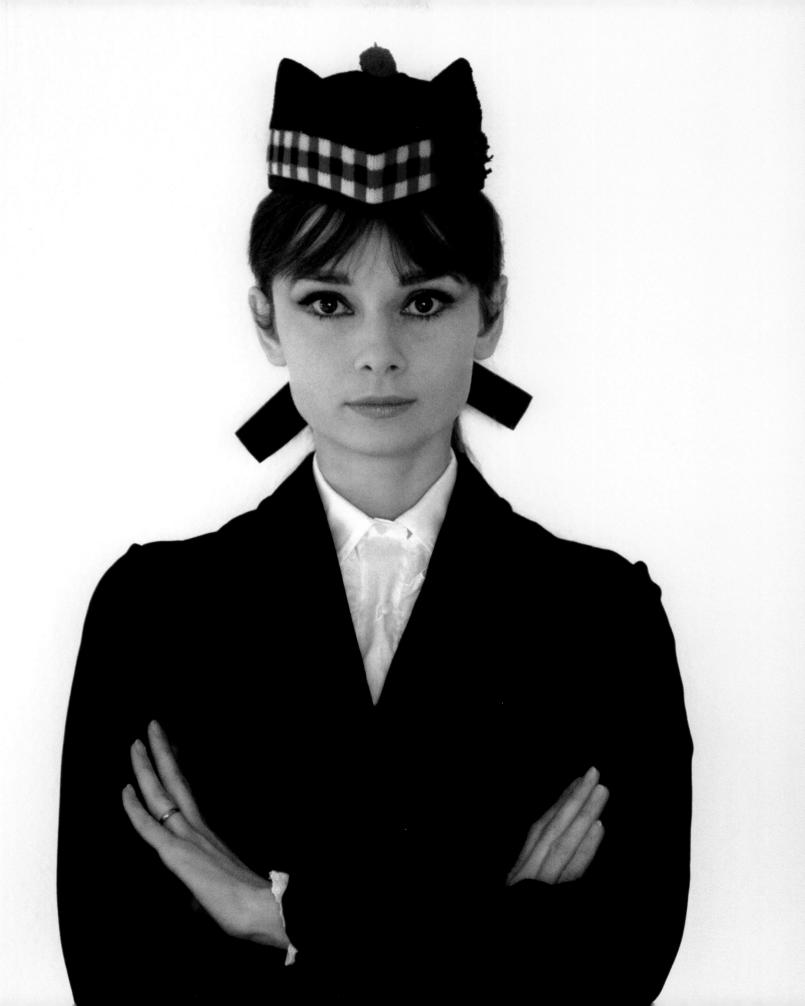

On location in 1958 in the Belgian
Congo during the filming of *The Nun's Story*, Audrey
is photographed in profile wearing a typical pith
helmet-shape, straw sun hat tastefully decorated in the
Ivy League style with a wide plaid ribbon.
Photograph by Leo Fuchs

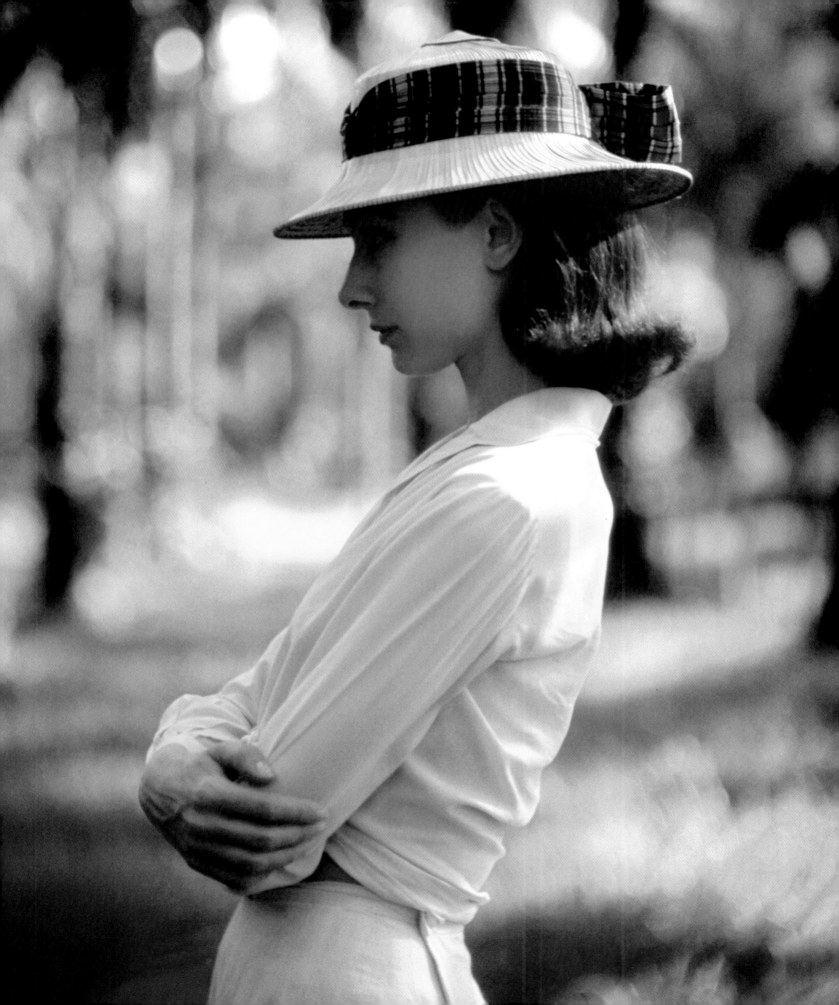

Audrey in an unfamiliar look as a Western
belle, on location for the film *Green Mansions* in 1958.
The broad brimmed, high crown cowboy hat
evokes all the adventure, freedom and seductiveness
of the old American West.
Photograph by Bob Willoughby

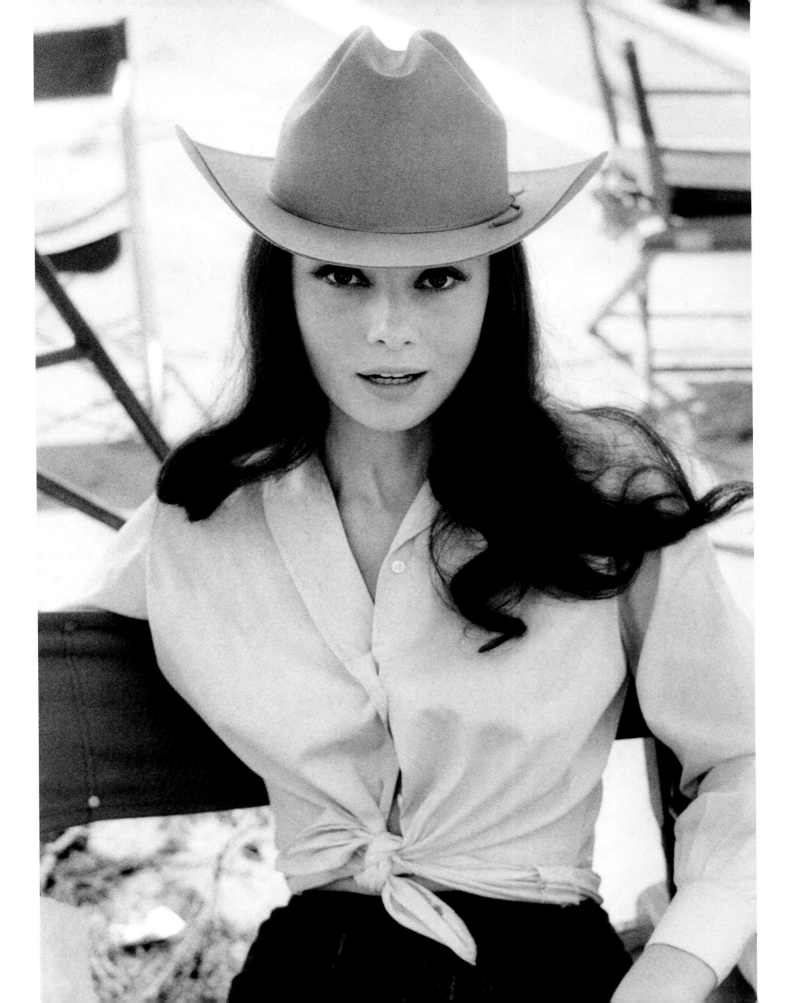

Taking a break on the set of *Paris When
It Sizzles*, Audrey poses for photographer Bob Willoughby
in immaculate style. The melon-shaped white felt
hat by Givenchy is typical of the period and is worn
formally by Hepburn's character, Gabrielle Simpson,
with long white gloves and a neat green suit.
Photograph by Bob Willoughby

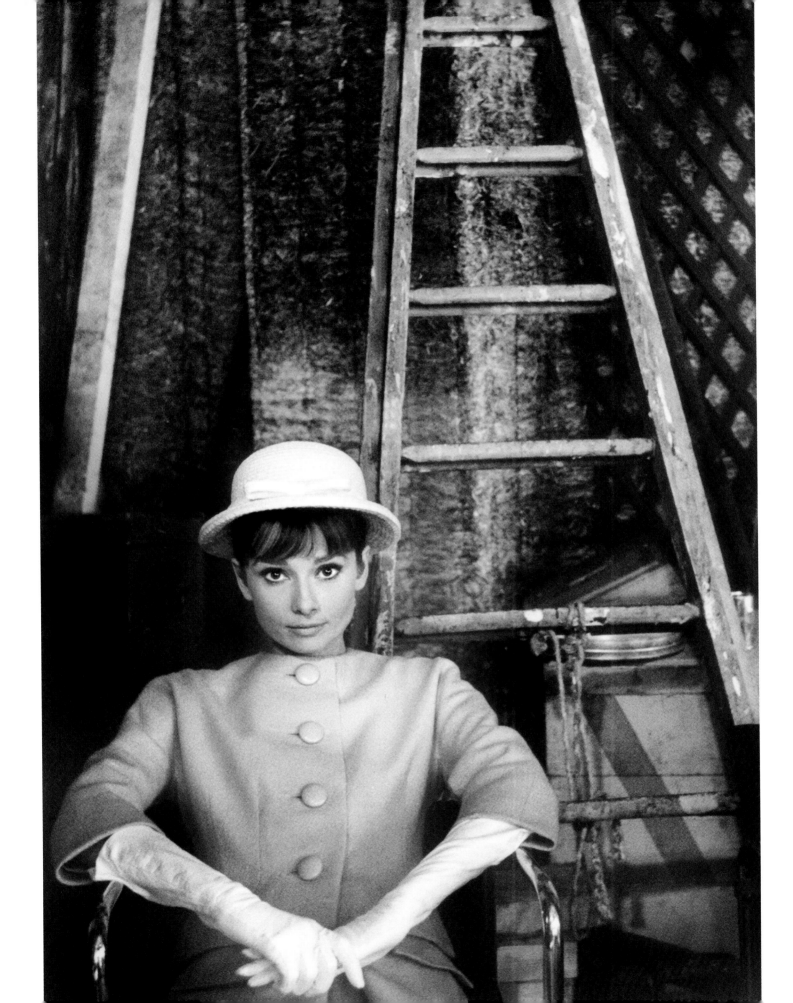

Audrey looks radiant in Givenchy's minimalist
creations in *Paris When It Sizzles*. This highly textured hat
moves elegantly and ensures Audrey stands out from
the crowd in the streets of Paris.

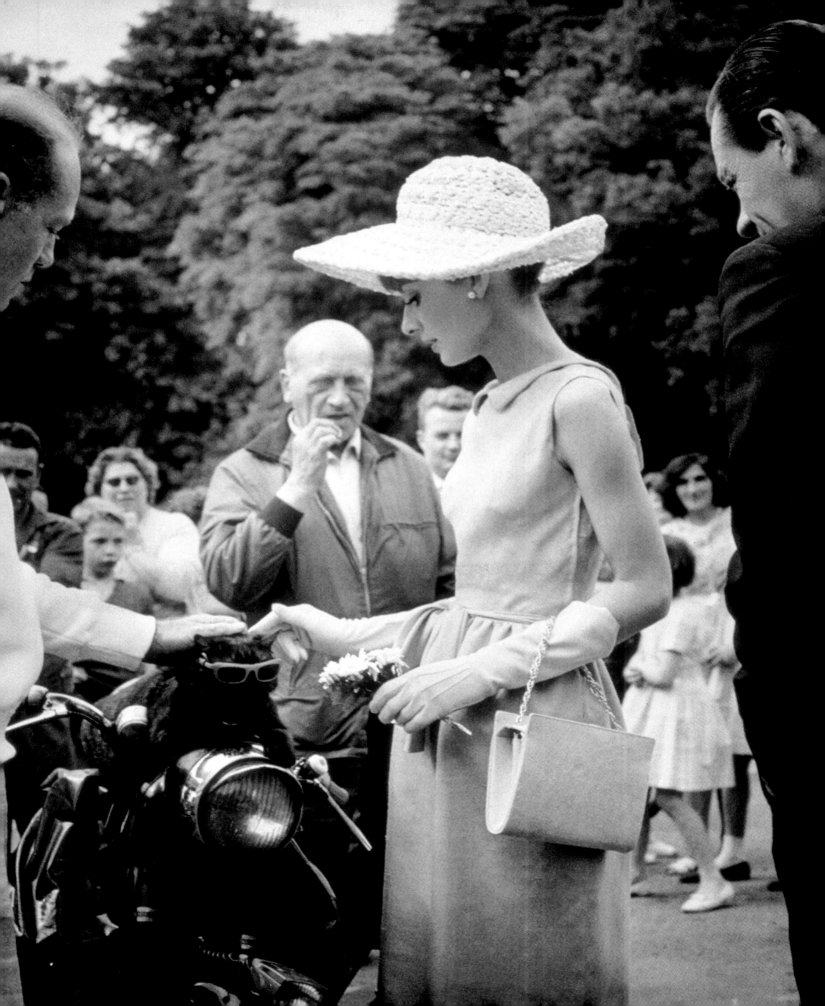

In her 1963 movie *Charade*, Audrey was
almost on home ground as filming took place in Parisian
and Alpine locations and dressing for a cool
climate required the appropriate costumes. Audrey looked
great in fur hats and this black beret style
was a practical and stylish choice.

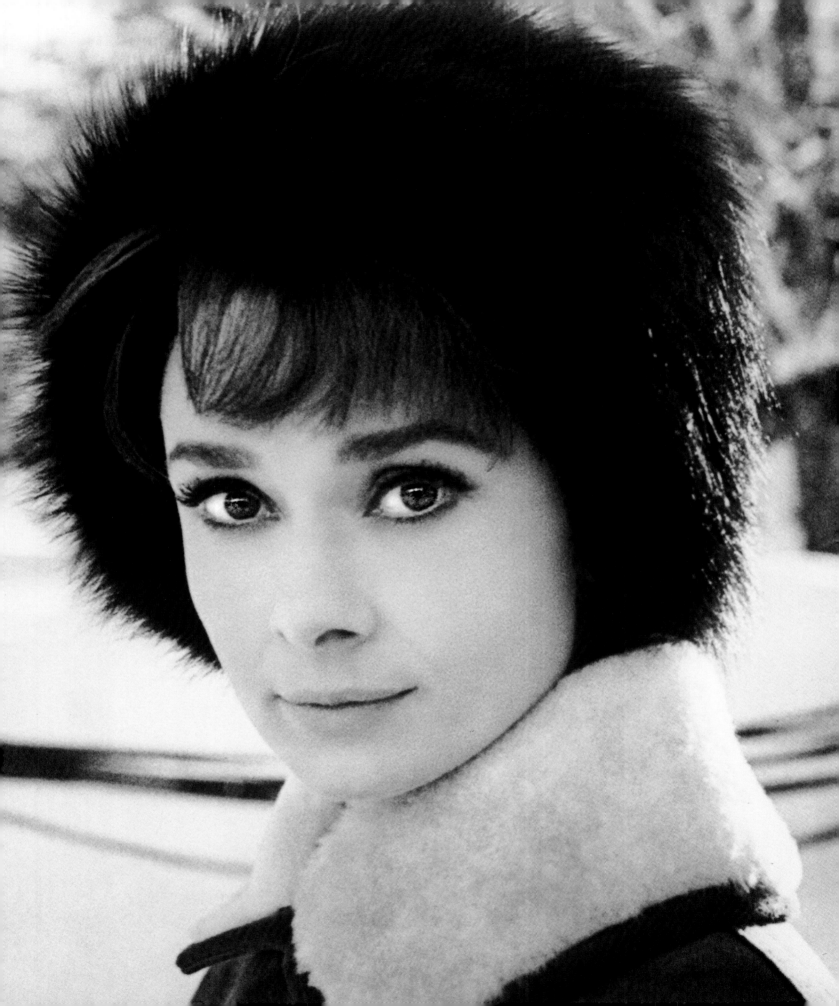

Audrey looked as good in her private
life as she did in her movies. Wearing signature dark
sunglasses, elegant pearls and a chic fitted dress
she was photographed in Paris in July 1962 wearing this
clean-cut, Breton-style summer hat.
Photograph by Pierluigi Praturlon

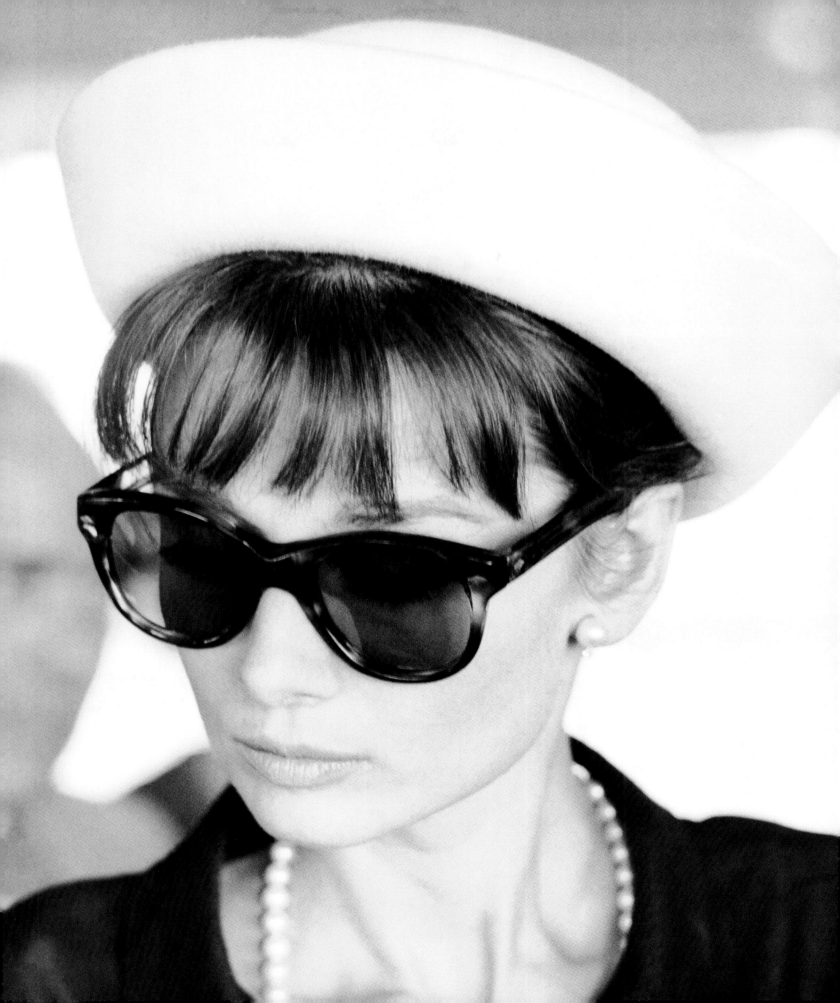

Cecil Beaton admired Audrey Hepburn from
their first meeting in the early 1950s, when he called by the
London home she shared with her mother to
interview her for *Vogue*. Beaton found her long, swan-like
neck attractive and in many of the portraits
of Audrey he drew attention to this feature. This Beaton
portrait from the 1960s highlights her elegant
profile with a velvet dome-shaped hat with silk tassels
falling from the back.
Photograph by Cecil Beaton

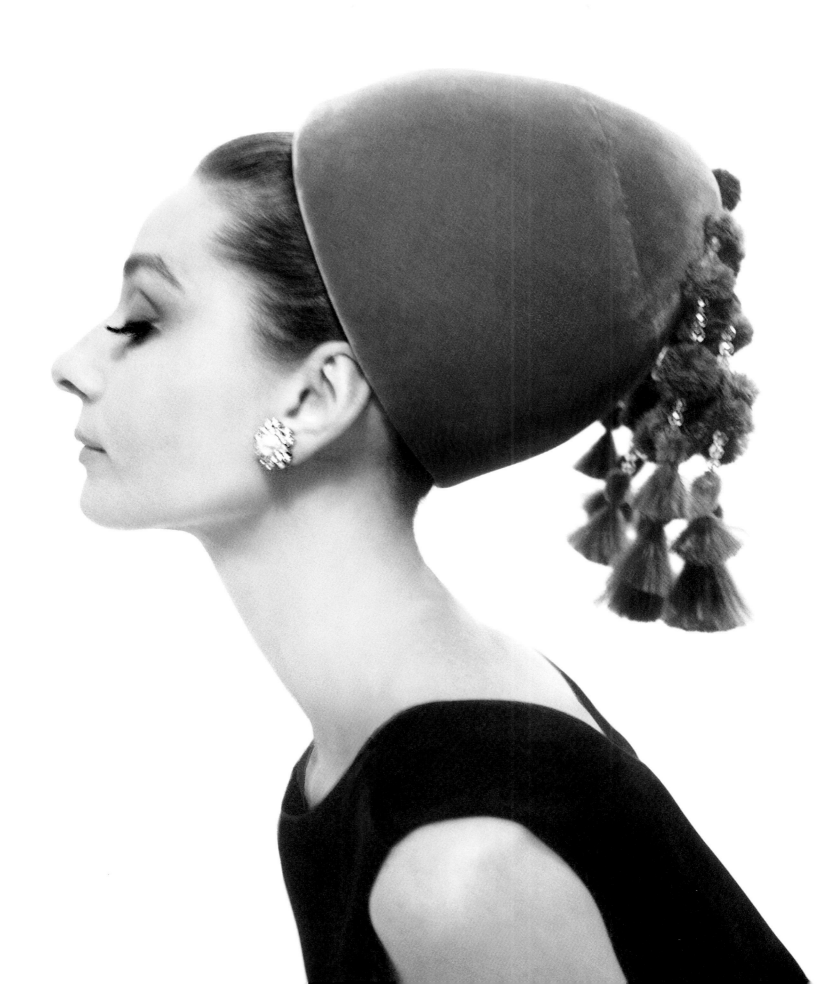

The great thing about the couture and
custom-made is that you can have the same style created in
many different materials, and this is
what Audrey did. A winter hat is made from felt with a
turned back brim in mink, which is very
similar to the white, Breton-style hat on page 73.
Photograph by Cecil Beaton

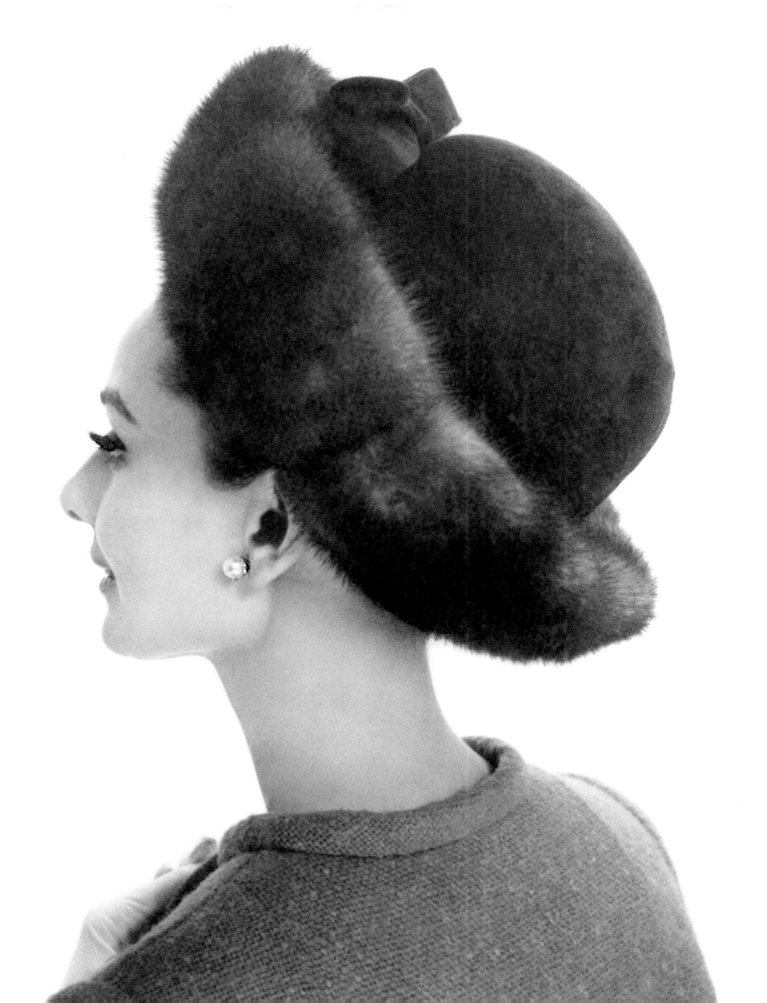

A whimsical, bonnet-shaped fur hat with
a round crown and rose decoration contrasts with
the sculptural profile of Audrey's hair
and costume in this portrait by Beaton.
Photograph by Cecil Beaton

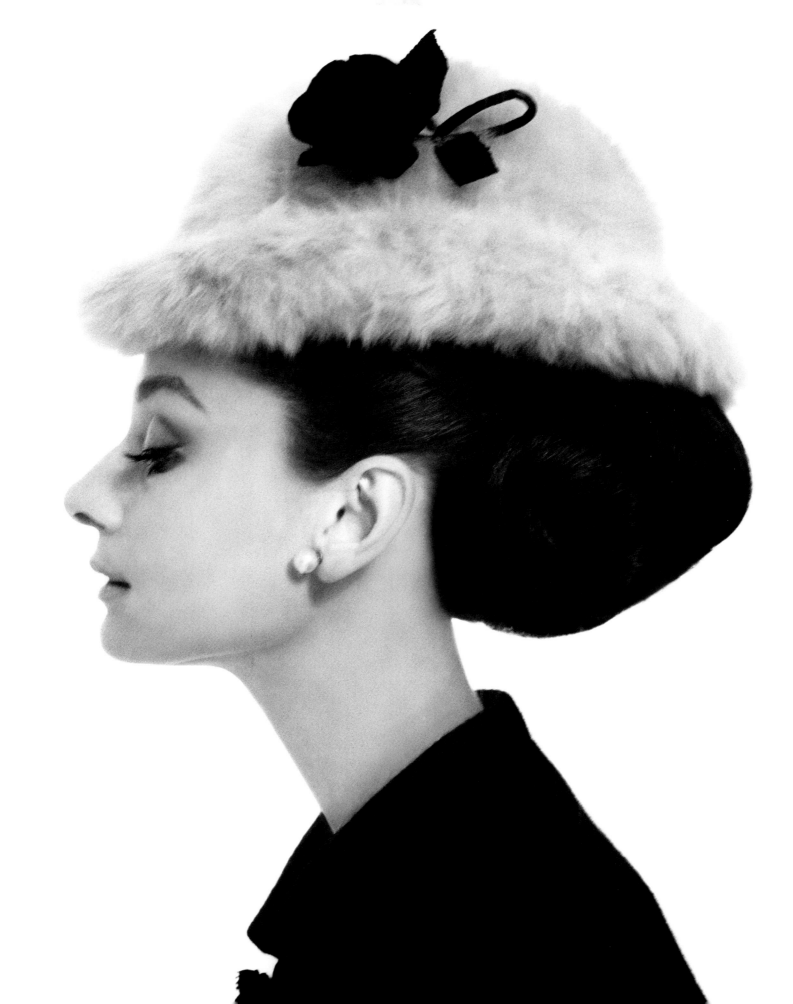

In the 1960s, Audrey found time to
pose in the studio for her friend Cecil Beaton. The
following pages show a series of portraits
of Audrey wearing various high fashion hats – just for fun.
A *toque blanche* in organdie with a stiff peak and bow
takes inspiration from the chef's toque.
Photograph by Cecil Beaton

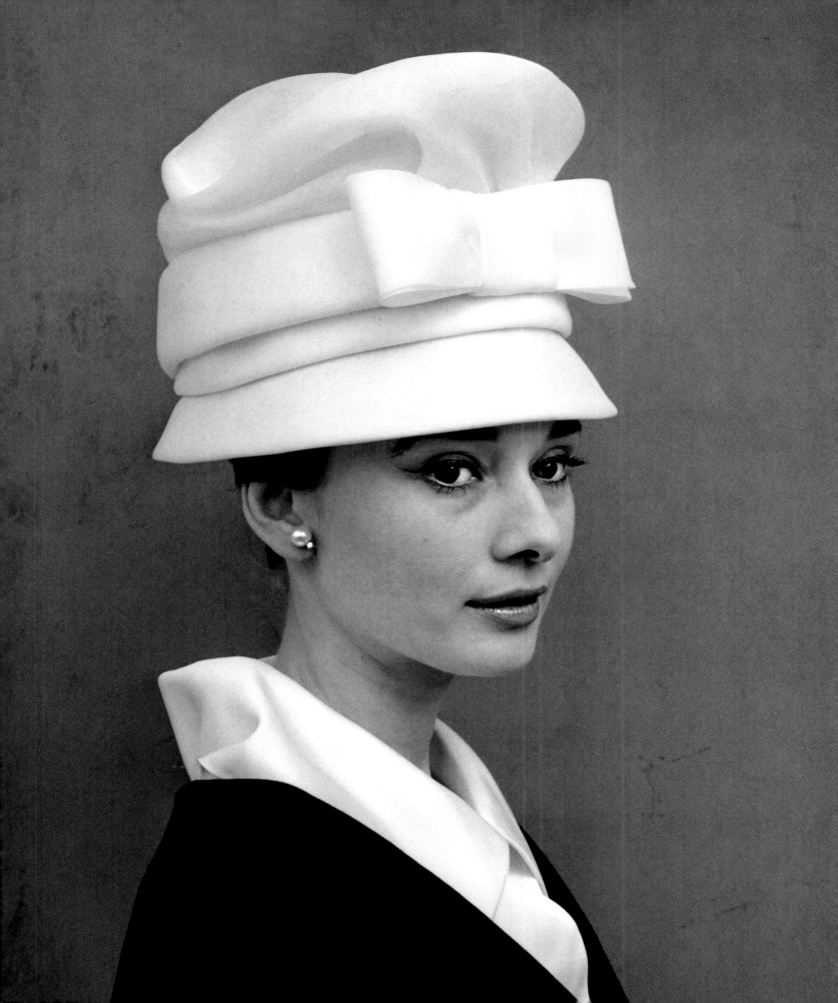

From the same series of photographs,
Beaton includes Audrey's Yorkshire terrier, Famous.
The hat she wears has a shallow crown in
white silk and features a large bow and rose decoration
at the front; it is quite plain at the back.
Photograph by Cecil Beaton

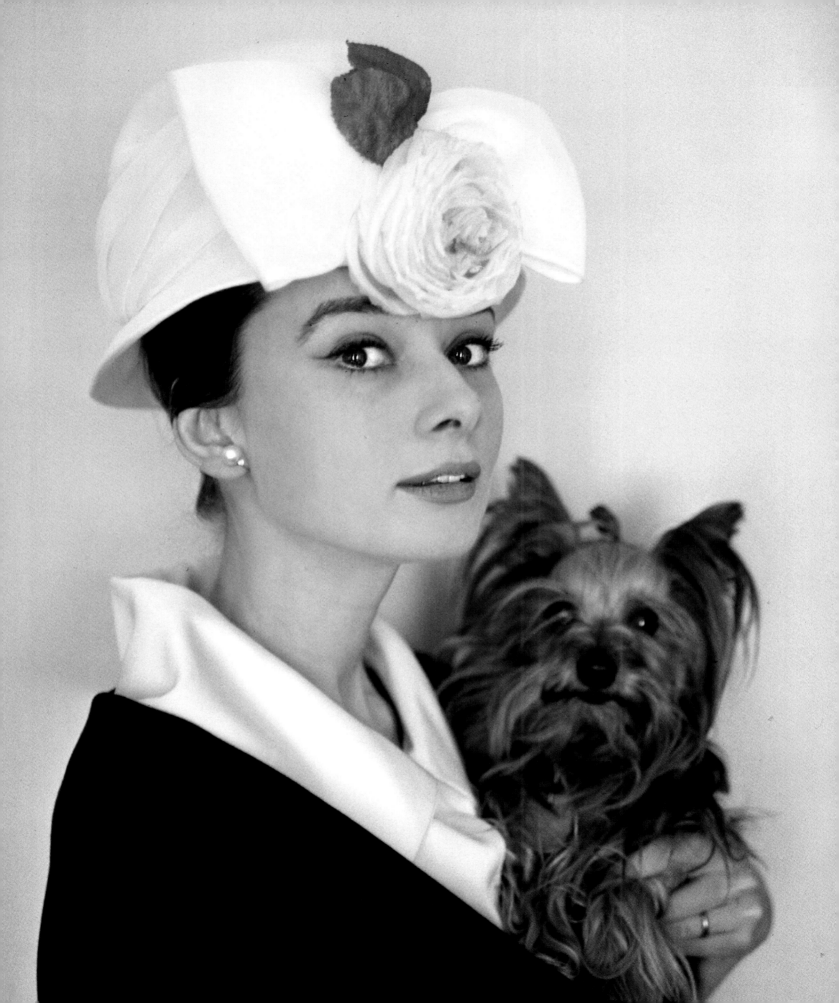

Audrey was taller than most actresses of
her era but had the confidence to wear costumes and
accessories that did not hide her stature. Toques were the
glamour statement of the decade and she wore them well.
This design is covered with red, shaded silk roses.
Photograph by Cecil Beaton

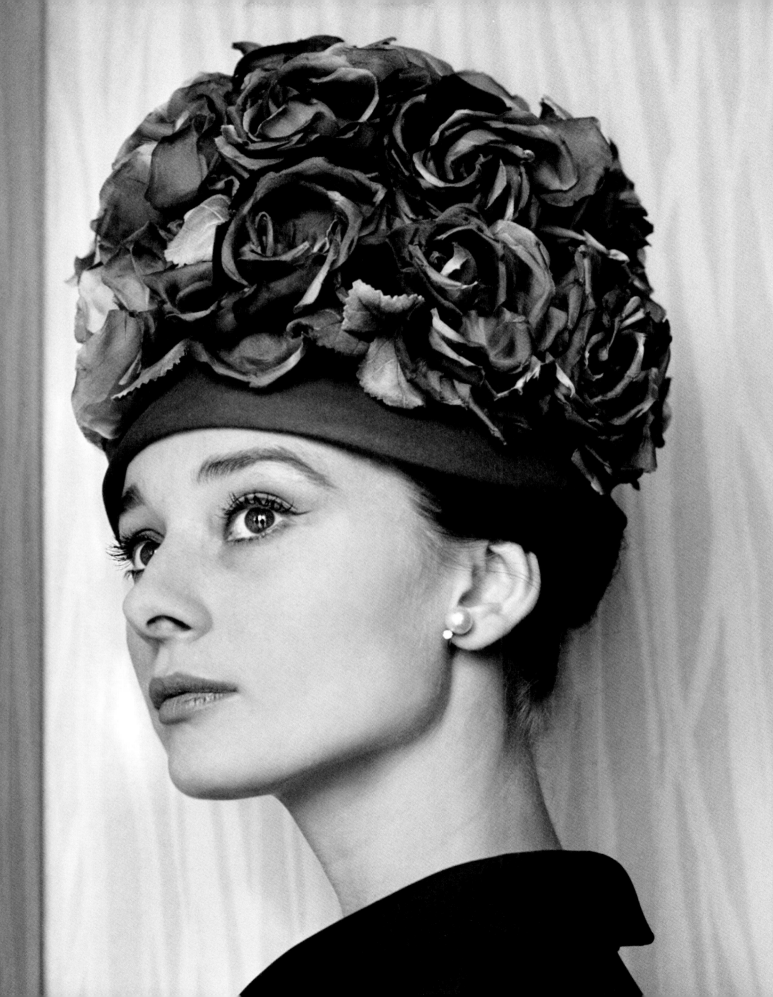

This was a classic 1960s hat design and a
popular shape both in couture and ready-to-wear. Made in
woven straw with a high crown and turned down brim
trimmed with a small bow, it was a versatile shape that
looked good with dresses, suits and coats.
Photograph by Cecil Beaton

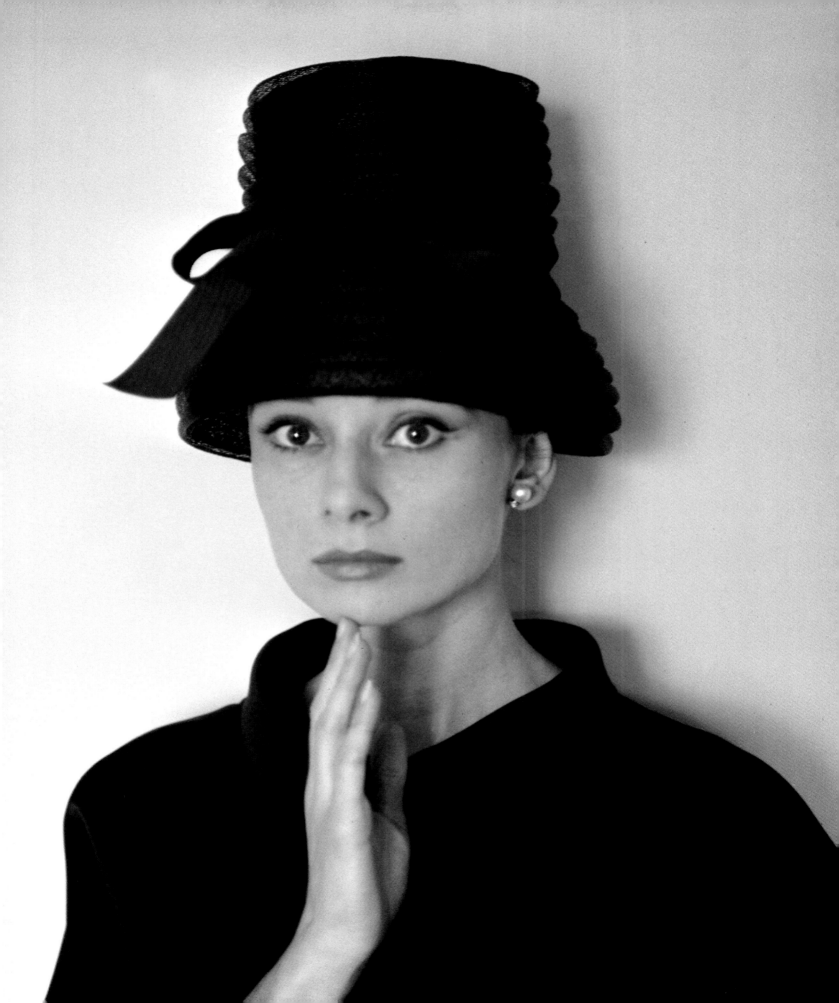

This joyful portrait of Audrey by Beaton appeared
on the cover of a June 1964 issue of *Vogue*. Audrey poses
in a pink chiffon turban with a white gardenia. From
the 1964 Jaipur Collection by Givenchy.
Photograph by Cecil Beaton

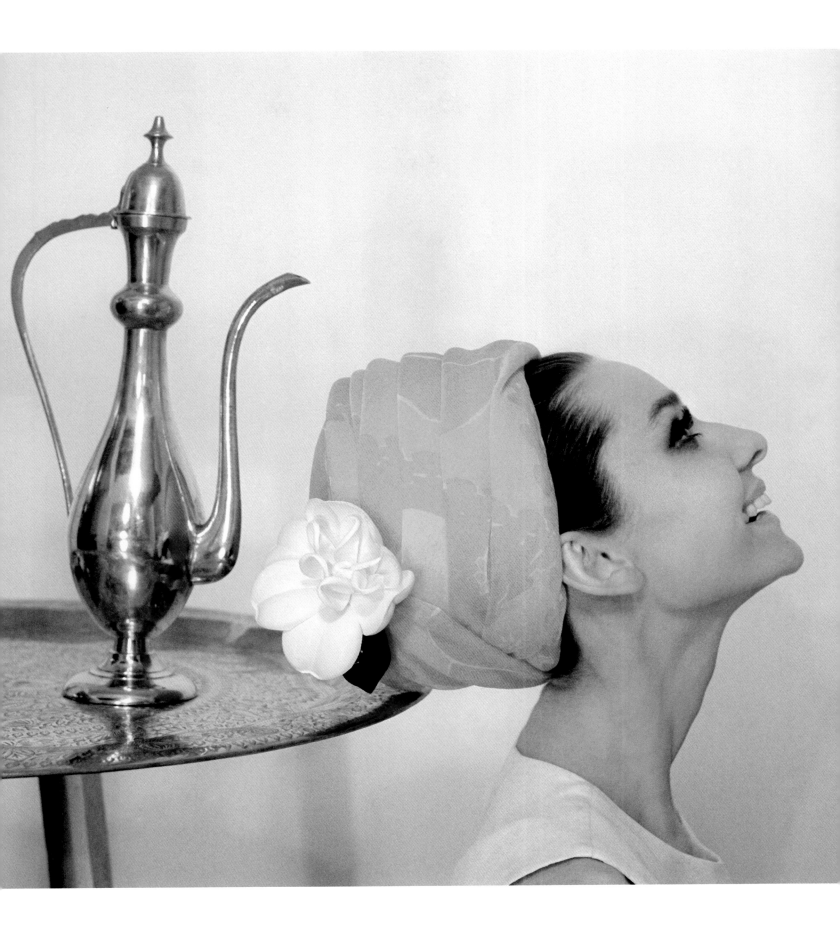

A striking Renaissance-style beret in
zebra-print stripes frames Audrey's sophisticated face.
In the 1970s, berets became very decorative
in patchwork, sequins and embroidery as part of the
burgeoning ethnic movement.
Photograph by Cecil Beaton

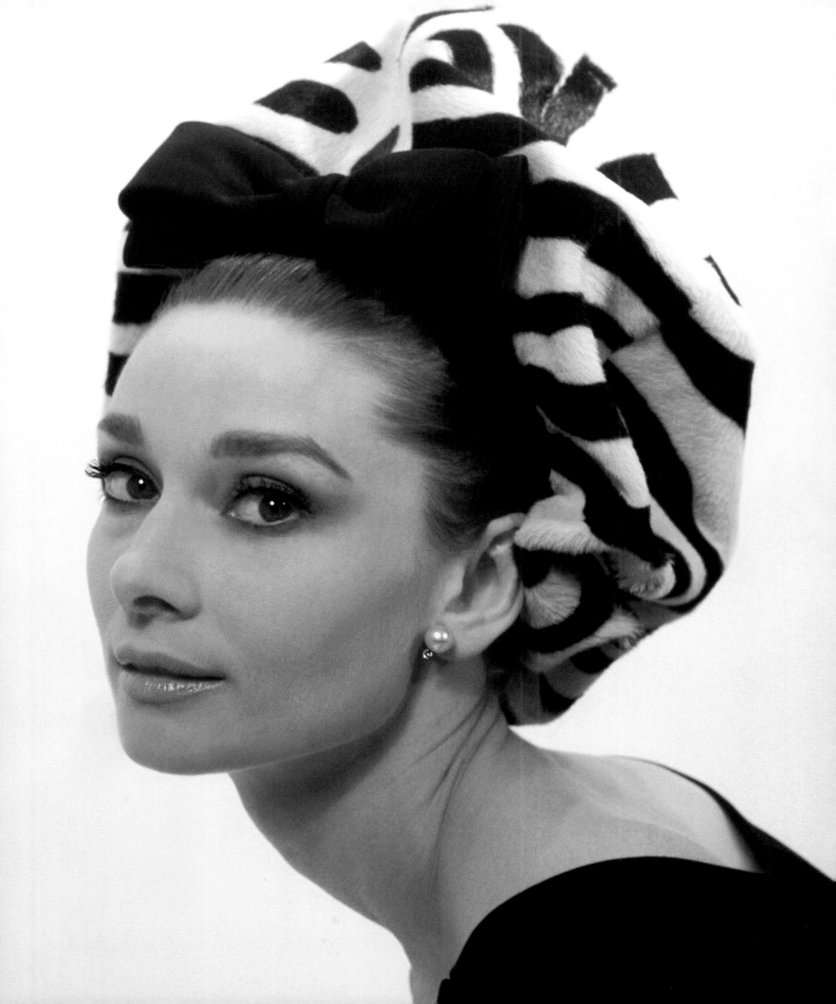

In Audrey's 1966 film *How to Steal a Million*, she looked very hip indeed in her Givenchy costumes, but then, Audrey will always be remembered for her immaculate appearance. This loosely belted coat and high crown trilby hat would not look out of place today on the catwalk.
Photograph by Douglas Kirkland

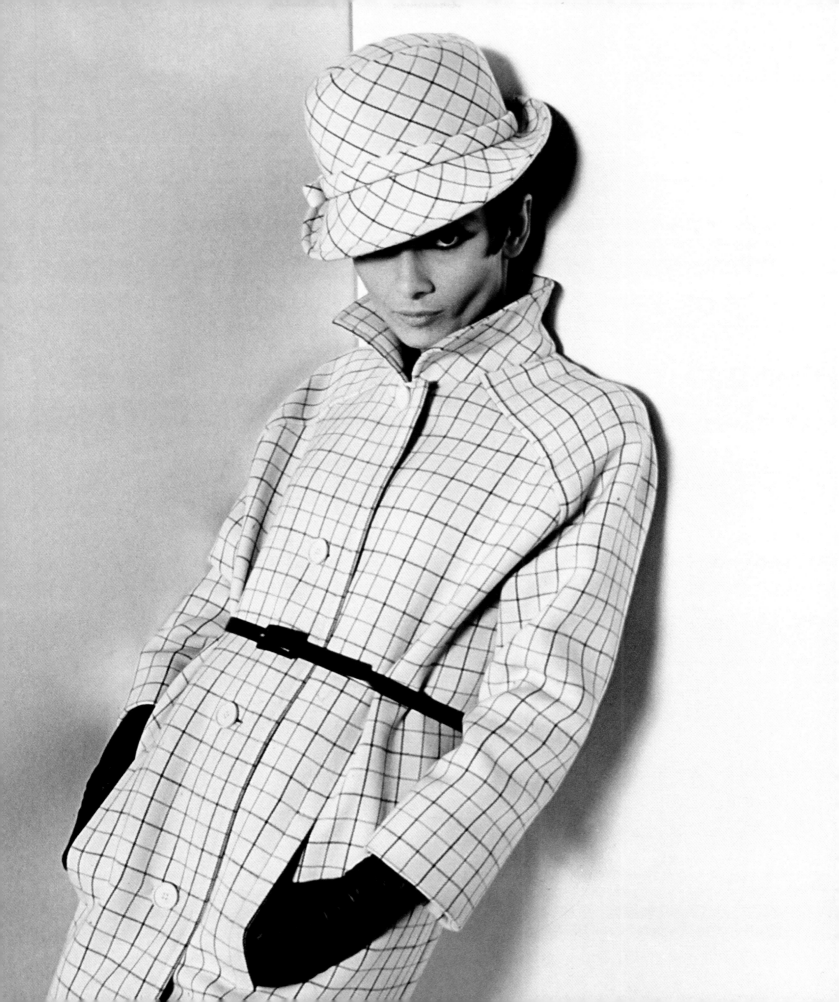

This dual purpose white Space-Age design
hat by Givenchy was the height of fashion in 1966, which
possibly doubled as a crash helmet when
Audrey was required to speed through Paris in an open-top
car in the movie *How to Steal a Million*.
Photograph by Douglas Kirkland

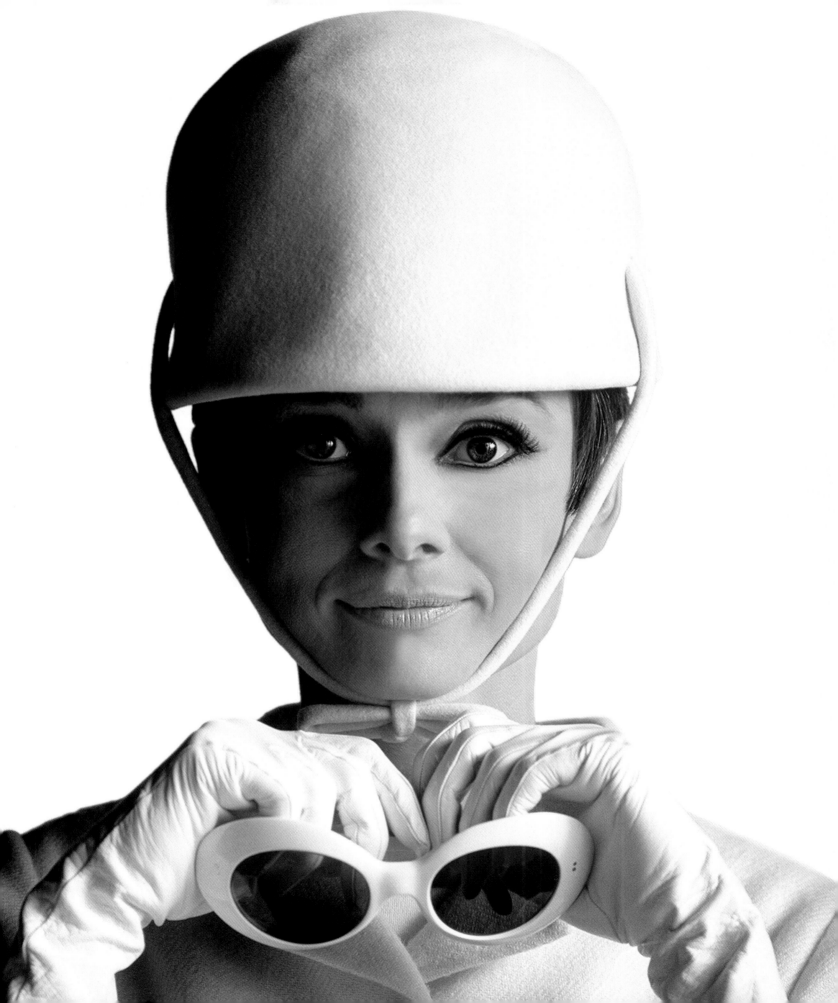

Audrey had a weak spot for the military-style
pillbox. It was the millinery must-have in the 1960s, worn
especially in the USA, where it was popularized
by Jackie Kennedy. In this off-set portrait, Audrey wears a
very smart Givenchy model in faux leopard.
Photograph by Douglas Kirkland

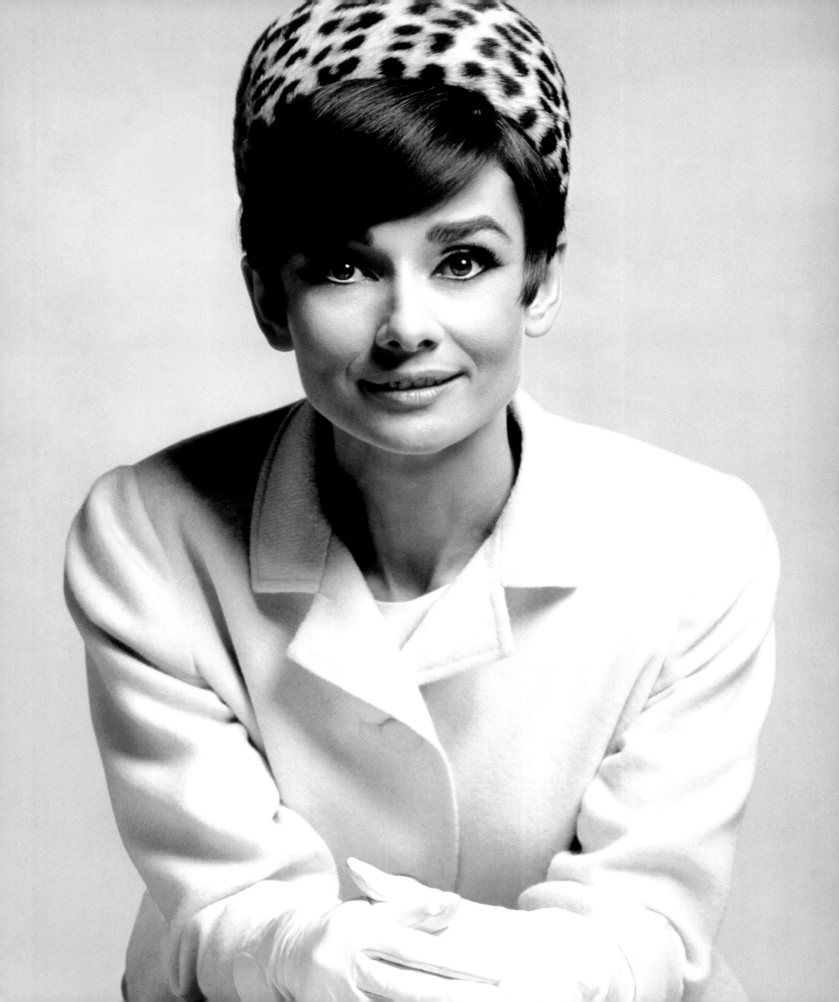

Audrey's passion for fashion meant
she was one step ahead; the first to try a new look.
This refined version of the Space-Age helmet
popular in the 1960s has a stiff peak and, as always, was
designed to avoid hiding Audrey's famous
big, brown eyes and beautifully shaped brows.
Photograph by Pierluigi Praturlon

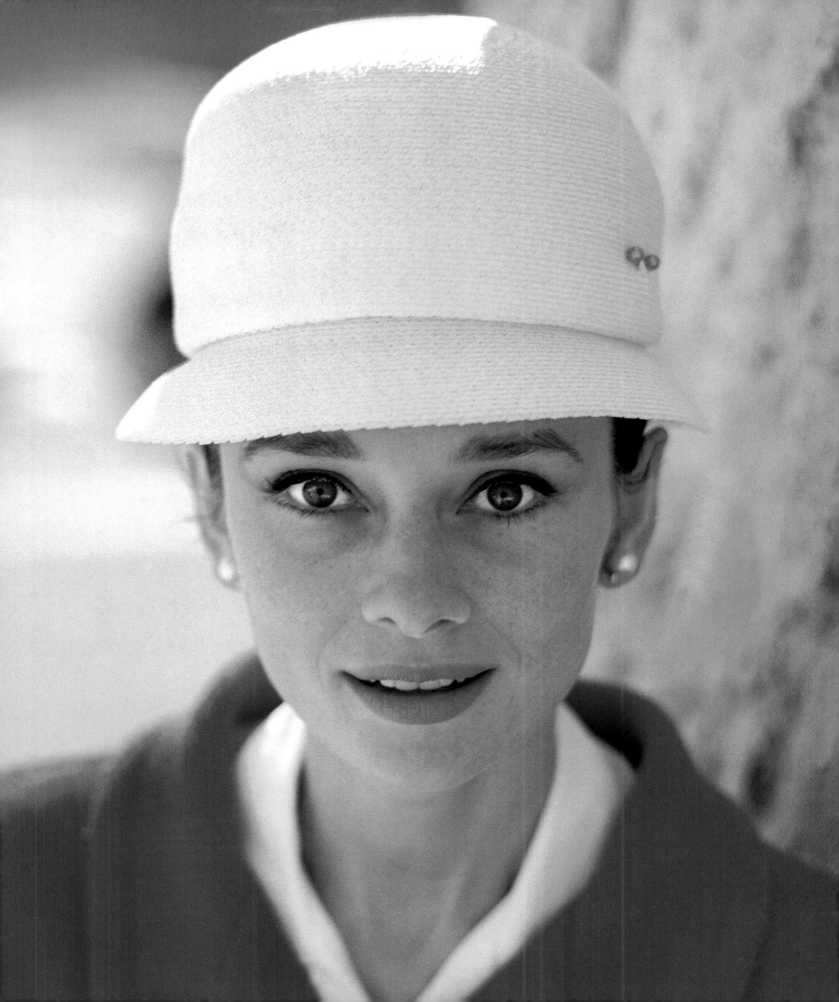

Headscarves do not have to look
unsophisticated, especially if Audrey Hepburn is
wearing one. The hat in this photograph is a
combination of the helmet and the headscarf, fashioned
in a classic French Provençal cotton print.
Photograph by Pierluigi Praturlon

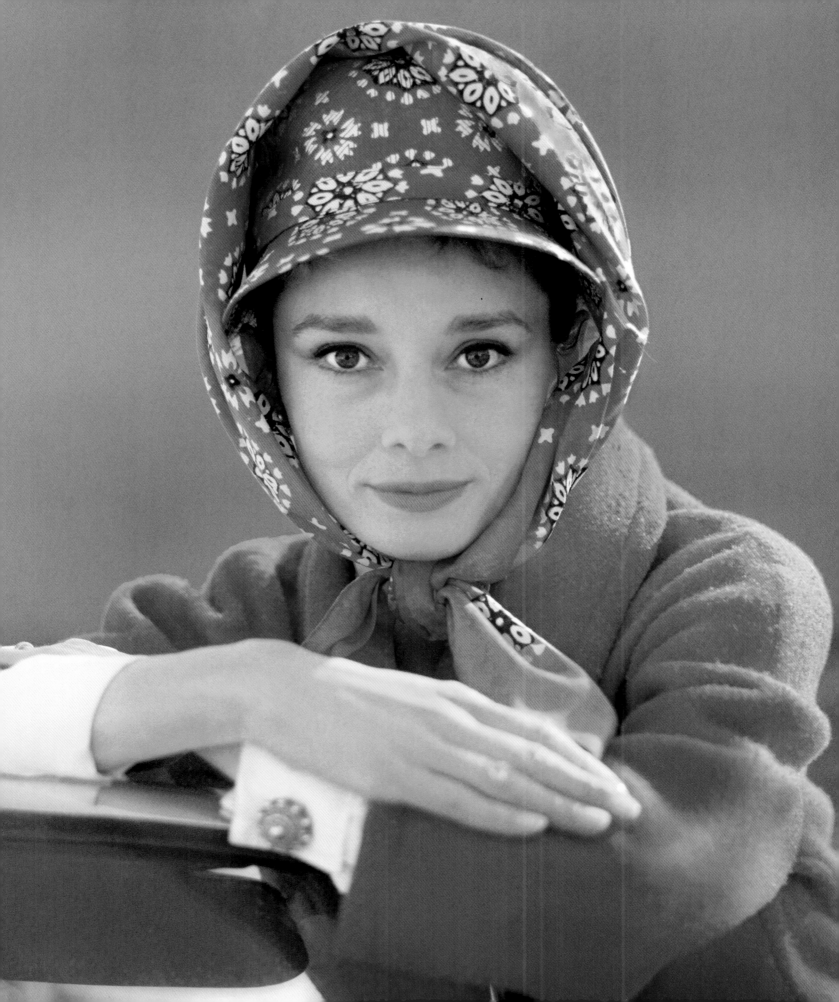

Even disguised as a house cleaner,
Audrey looks beautiful. She is wearing a soft felt
hat in the Tyrolean style in this picture, captured on
the set of *How to Steal a Million*.
Photograph by Terry O'Neill

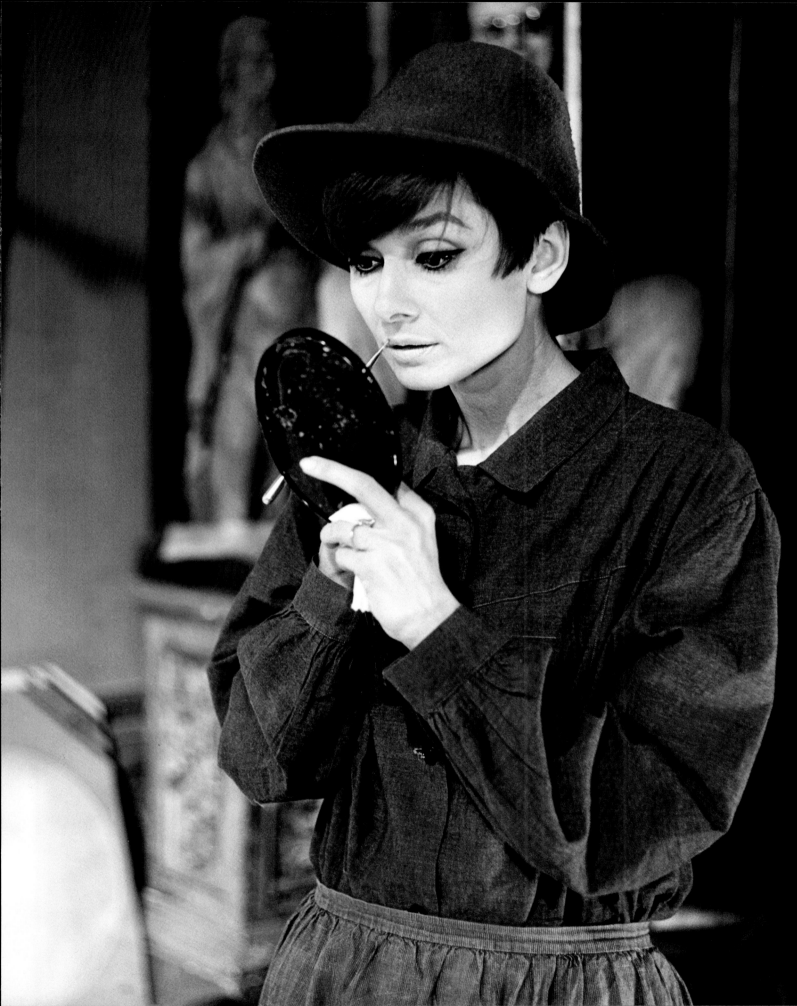

MY FAIR LADY

My Fair Lady was the most spectacular and highly paid role of Audrey Hepburn's career and Warner Bros highest grossing film in their history to that time. And although it cost over $17 million to make, every cent of this huge budget can be seen on the screen, especially in the lavish costumes and hats Audrey wore.

When Hepburn arrived at the studio for her first meeting with Cecil Beaton, who designed all the costumes for the film, she was so impressed that she insisted on trying on many of the extras' gowns, complaining that her role and leading character, Eliza Doolittle, did not get enough pretty clothes. As a result, Beaton arranged with Warner to spend two days photographing Hepburn in most of the women's costumes. He ended up taking over a thousand pictures of her in 400 spectacular costumes, of which we have selected some of our favourites for this book. I suspect this was also a way of Hepburn getting into character for her role in the movie. *My Fair Lady* was set in Edwardian London and shot entirely in Hollywood studios. It was a musical comedy and a marvellous showcase for the creative talents of Beaton, Warner's costume department and the Art Director, Gene Allen. The film was adapted from the non-musical comedy *Pygmalion* by George Bernard Shaw. He had written the play partly to satirize British notions of aristocracy.

The story begins when phonetics professor Henry Higgins bets a colleague, Colonel Pickering, that he can transform Eliza Doolittle, a Cockney street vendor, into a Duchess simply by teaching her to speak proper English. Pickering accepts the wager and Eliza agrees to the challenge because she desires to improve her station in life. Higgins invests all his time and energy in Eliza's transformation, with the final goal passing her off as an aristocrat at the season's biggest social event. In the process, the relationship between teacher and student grows from dislike to something more profound and unexpected.

At the beginning of the twentieth century hats grew larger and larger and by 1907 had attained an incredible size. Outrageous feather hats became fashionable for women – the bigger and more decorative the hat, the higher the status. Hats perched straight and high upon the head, they were both large and small, some with brims so broad they extended the wearer's shoulders. Trimming stood upright. Ostrich plumes, paradise feathers, aigrettes, heron wings, stuffed birds and wired bow-knots of ribbon, velvet and lace all rose upward. Feather quills were also fashionable as a new decoration. Flowers such as violets, roses and garden species were used as additional embellishments. These hats were made in felt, straw and varied fabrics according to the season.

Adorning the human form is amongst the world's best-known outlets for artistic expression, and in this musical comedy Cecil Beaton had a field day. He designed the most extraordinary amount of beautiful costumes – most of them for the extras to wear in the Ascot scene. Audrey only got to wear a handful in her role as Eliza but the white ball gown she wore was a genuine antique flown in from England. When she entered the set for the first time in it, she looked so beautiful the crew and the rest of the cast stood silently gazing at her, then broke out with applause and cheers.

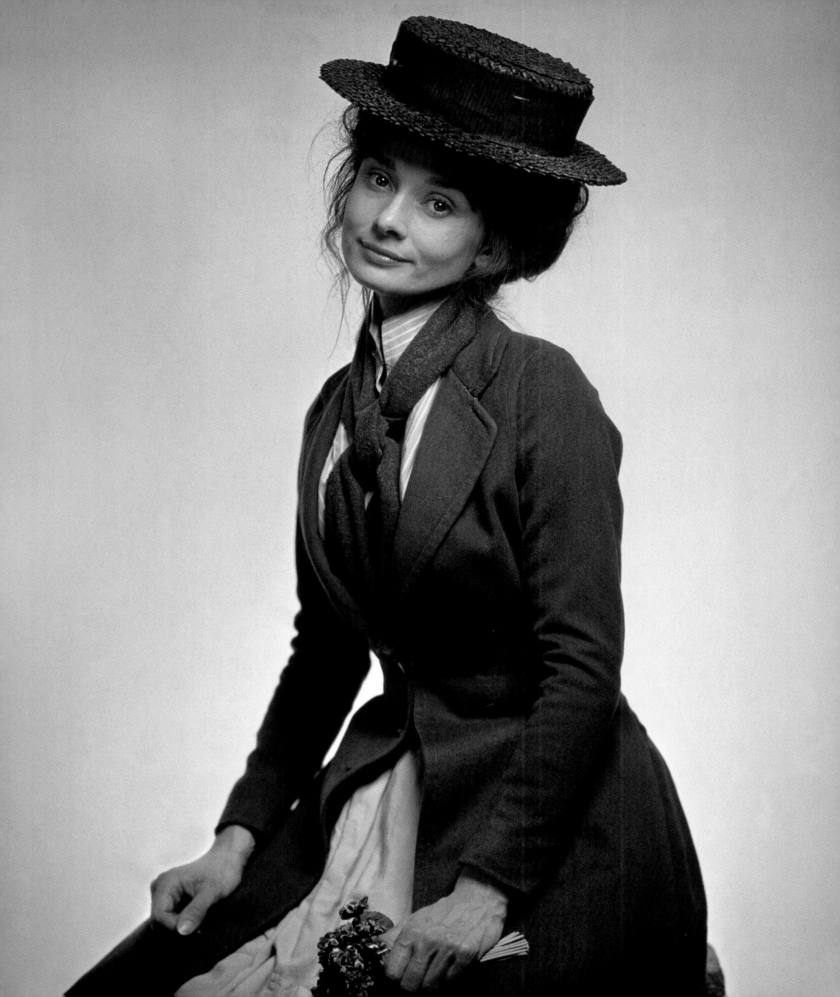

Fashionable and affordable for the
working girl at this time were straw hats decorated
with beautifully dyed goose or chicken feathers. The
one Audrey wears when she visits Professor Higgins at his
home is in dramatic pink and orange.
Photograph by Bob Willoughby

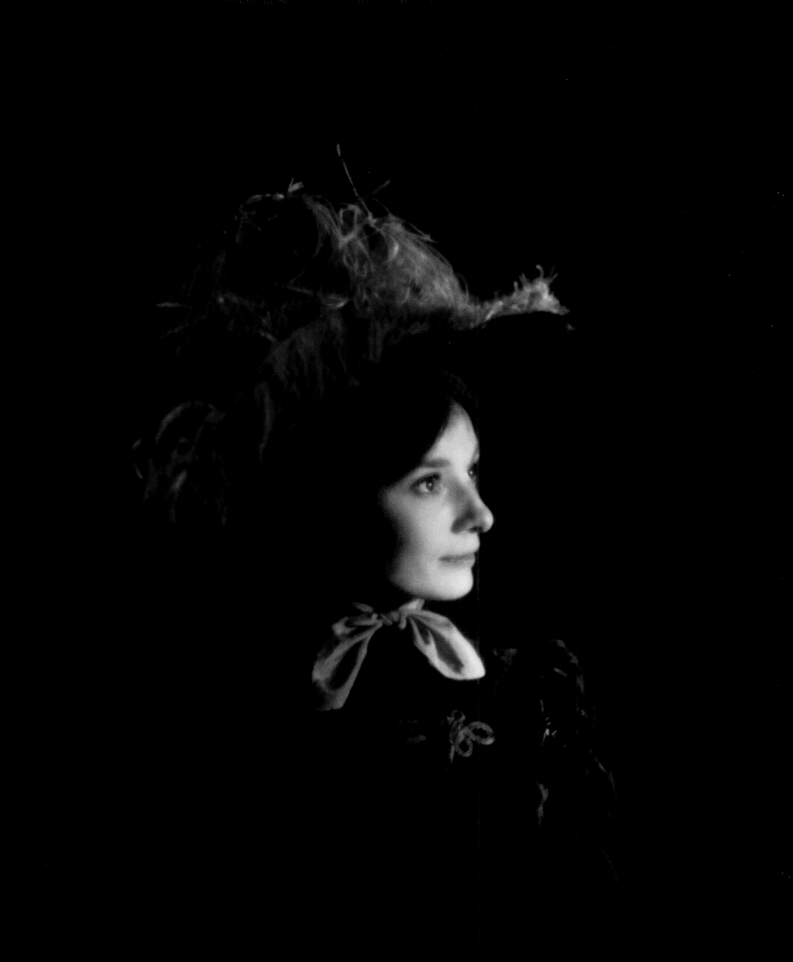

The most famous costume from *My Fair Lady*
is this slim, floor-length white lace dress trimmed in black
and white ribbon. Audrey wore it in the
Ascot scene. Beaton cleverly added red and pink flowers to
Audrey's magnificent hat so that she would stand
out from the crowd. Inspiration for the all black and white
costumes for this central scene in the movie
came from when, after his death in 1910, Edward VII
was paid the compliment of 'Black Ascot':
every woman wore mourning dress and trimmed her
hat with black feathers, crêpe and lace. It was
the most elegant Ascot ever!
Photograph by Cecil Beaton

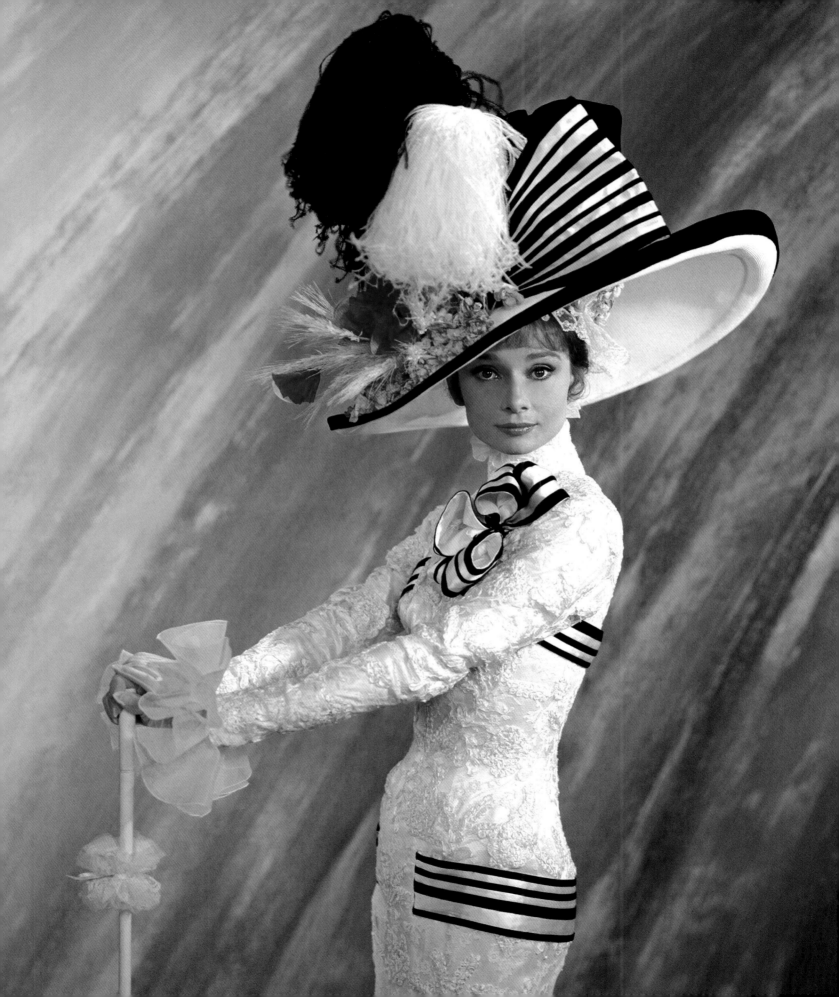

Audrey's scoop-shaped straw hat is worn at
a very straight angle, giving it a Chinoiserie flavour,
decorated fashionably with ribbon,
flower and fruit.
Photograph by Cecil Beaton

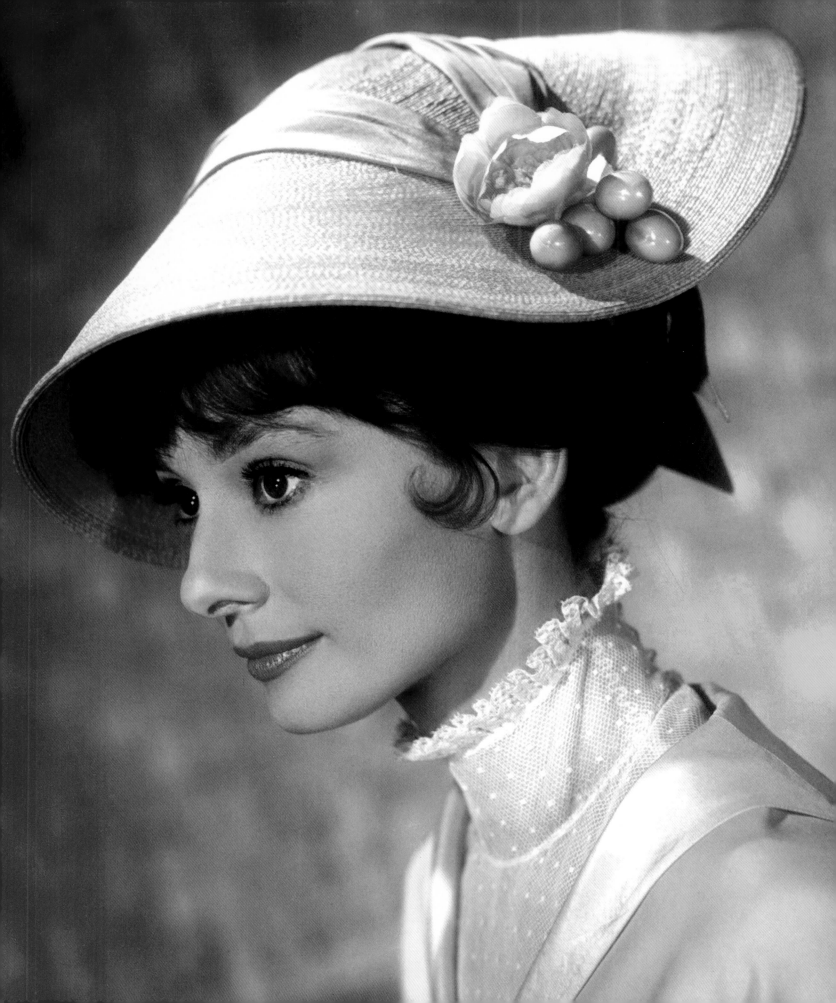

This enormous hat, made for one
of the extras in the Ascot scene in *My Fair Lady*, extends
beyond the width of Audrey's shoulders. It features
a large black bow and white ostrich plumes.
Photograph by Cecil Beaton

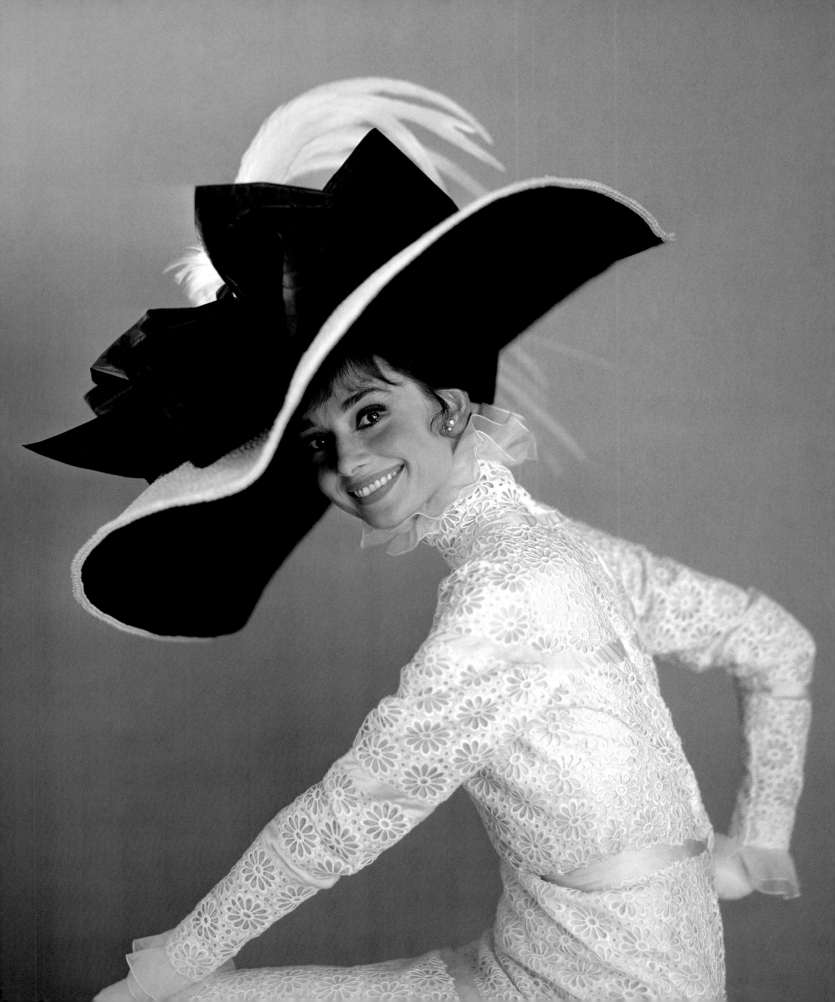

This towering toque in pleated chiffon
has a fanciful plume of feathers on top, typical
of the period. In this shot Hepburn wears
her favourite pearl earrings and pearl necklace.
Photograph by Cecil Beaton

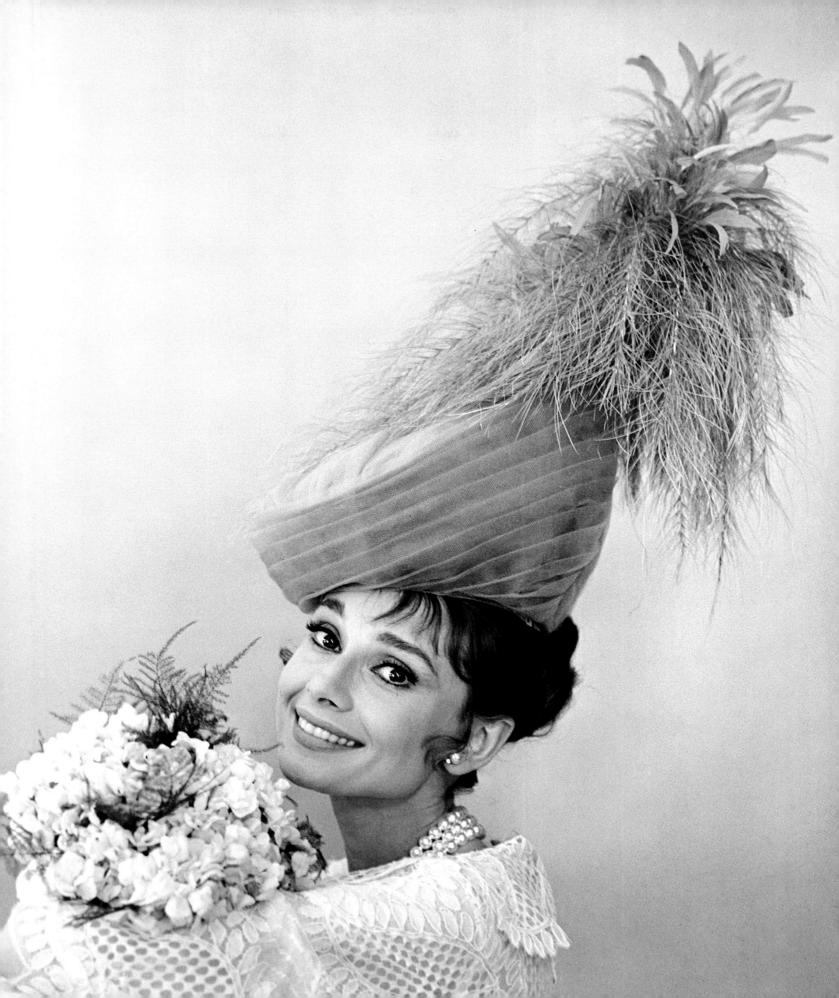

Another hat of enormous proportion,
white on the outside with black inside the wavy brim, is
decorated simply with white tulle to imitate
the petals of an oversized flower.
Photograph by Cecil Beaton

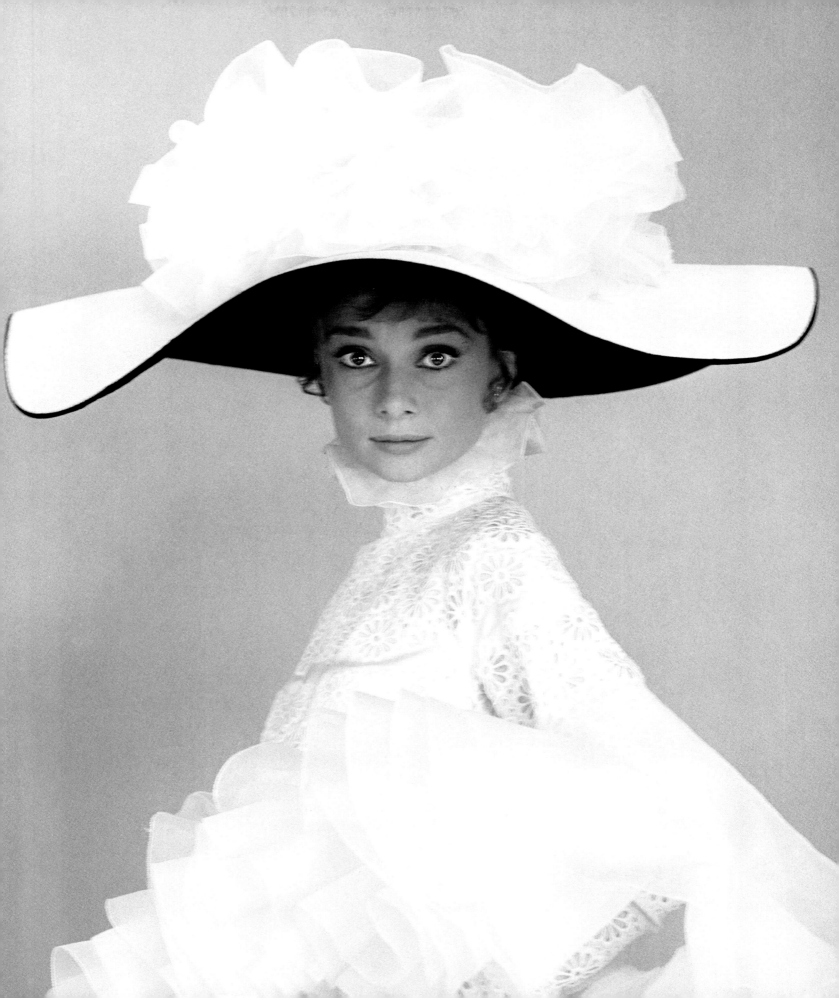

A most unusual and stunning evening
hat with a lustrous sheen pleated to a tapering crown
and decorated with aigrette feathers.
Photograph by Cecil Beaton

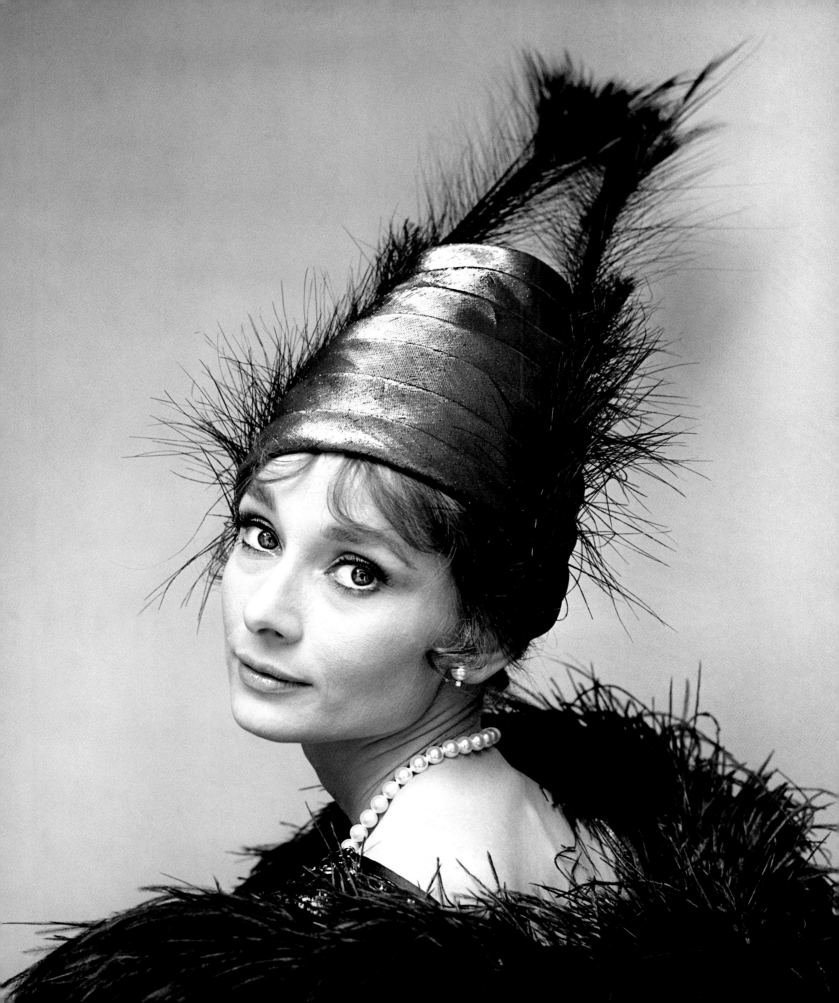

Audrey is clearly enjoying herself posing for
Beaton in these elegant costumes that have been perfectly
researched and executed for the movie. This
white bell-shaped hat is trimmed with a gigantic
bow heading upwards.
Photograph by Cecil Beaton

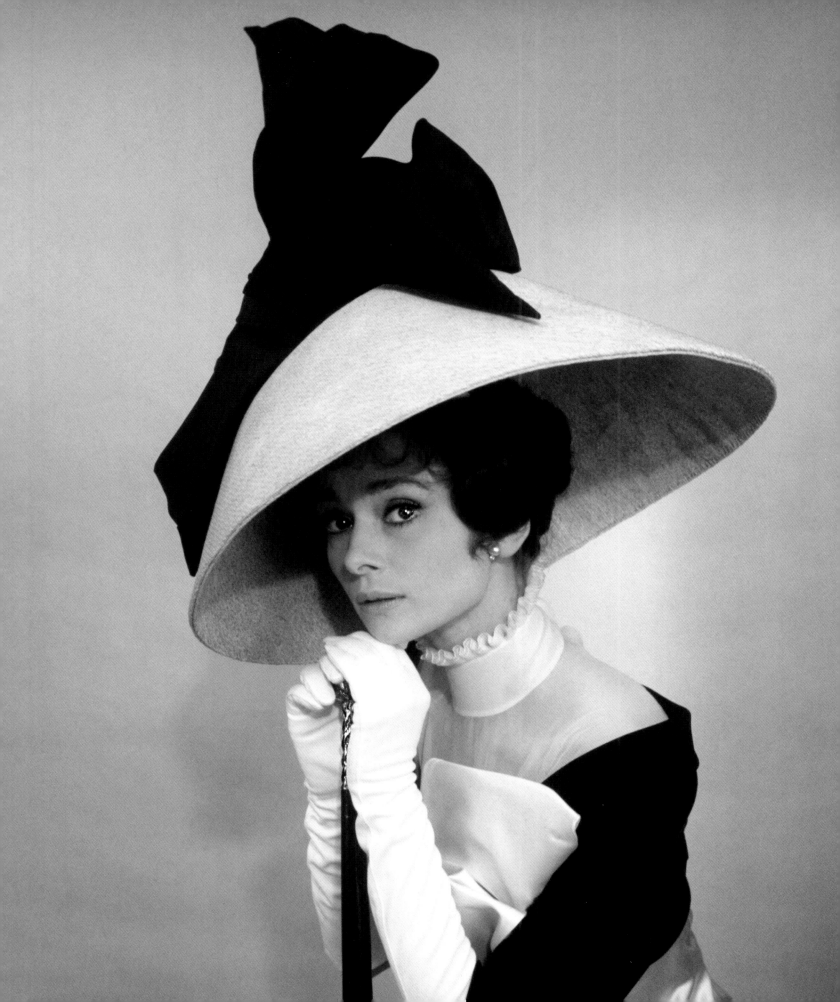

This costume is altogether more understated
than many of the other costumes in the film and looks
ultra-chic on Audrey. The hat in grey silk is worn at a sharp
angle and draped with silk and white roses.
Photograph by Cecil Beaton

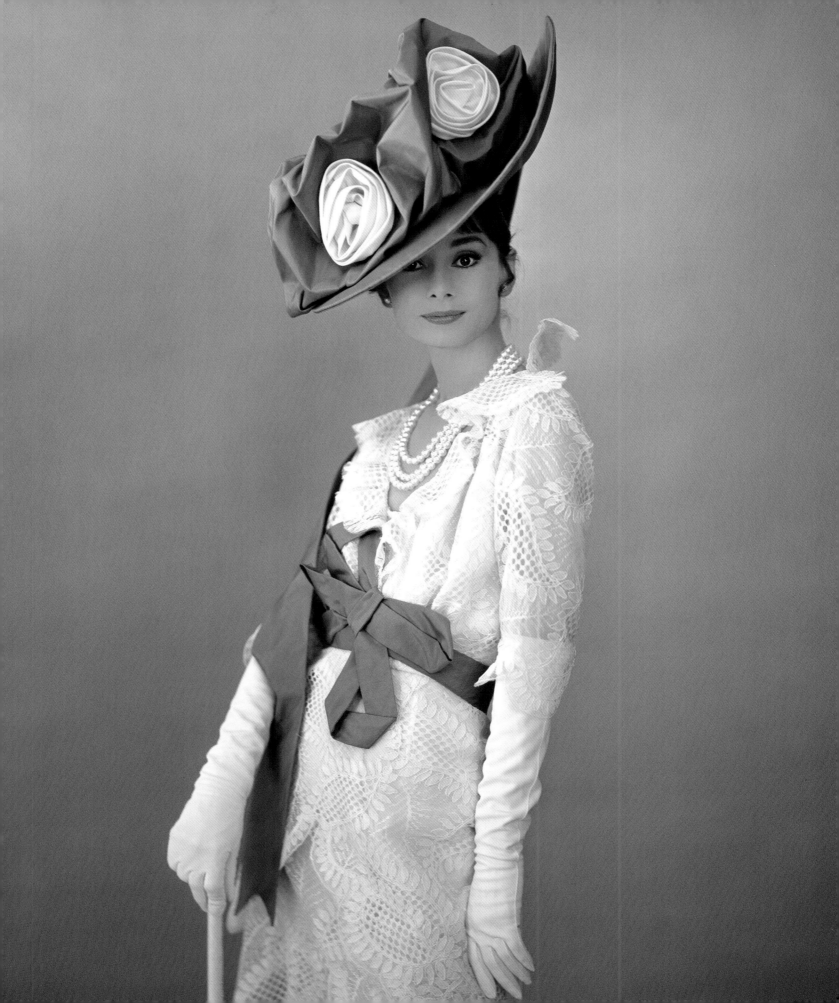

Looking fabulous at 50, after a three-year
hiatus Audrey starred in *Bloodline* (1979). Audrey's role
was Elizabeth Roffe, the heiress of a pharmaceutical
tycoon. Her costumes were, of course, made by Audrey's
loyal friend Hubert de Givenchy and saw her
stylishly through the movie. In this photograph she is
wearing a wide brimmed, fine straw picture
hat decorated with red flowers that give her face a
warm and a youthful glow.

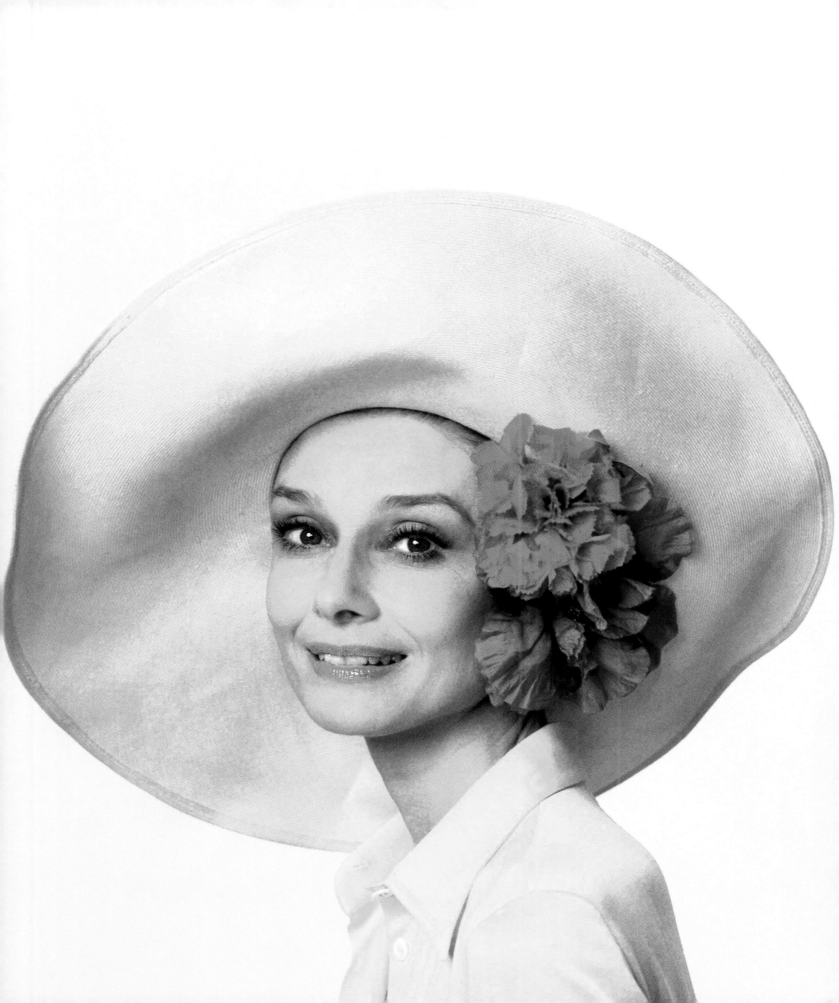

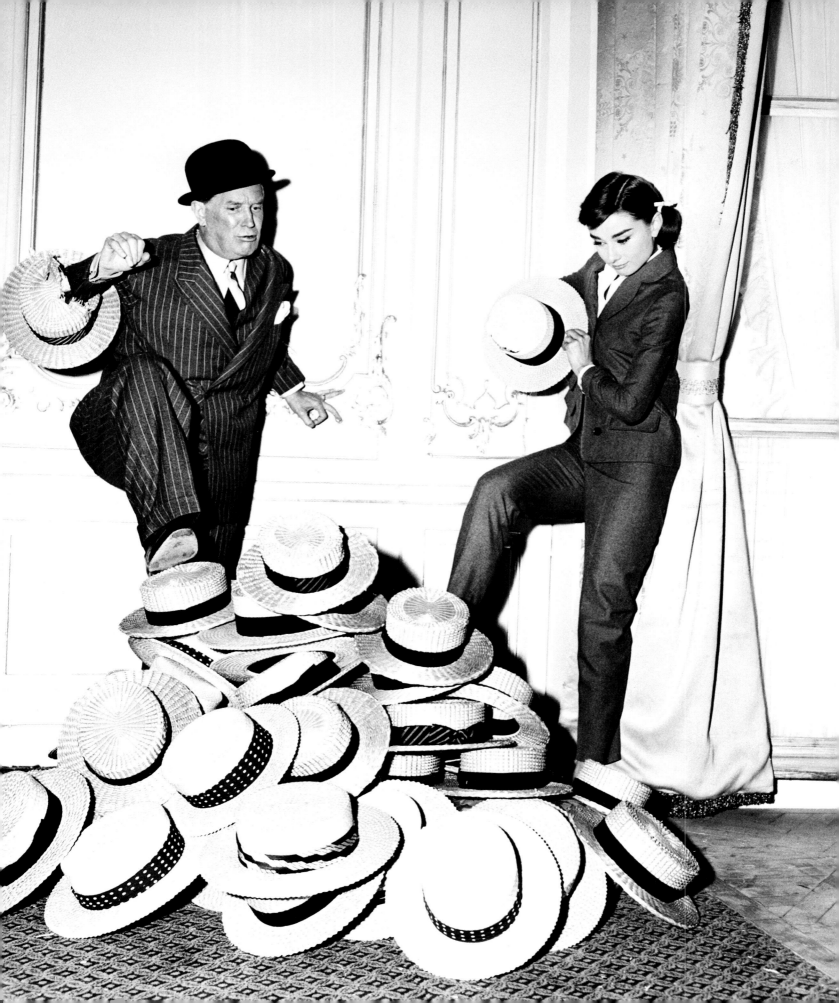

ACKNOWLEDGEMENTS

Thanks to Tony Nourmand for his tireless picture research and editing, to Graham Marsh and Jack Cunningham for their patience and stylish design ideas and to ace text editor, Ali Elangasinghe. Thanks to my family. In memory of Charlie Palmer.

Reel Art Press would like to thank the following friends and colleagues for their continual help and support: Bob Adelman, Stephen Atkinson, Ron Avery, Lisa Baker, Joseph Baldassare, Jonathan Bell, Daniel Bouteiller, Luisa Brassi, Joe Burtis, James Butcher, The Crew from the Island, Priya Elan, Christopher Frayling, Leslie Gardner, Richard Garvey, Marc Glanville, Richard Harris, Ron Harvey, Andy Howick, Beth Jacques, Andy and Maria Johnson, Dave Kent, Todd Lifft, Sara Lindström, Howard Mandelbaum, Ron Mandelbaum, Katherine Marshall, Rick Mayston, Phil Moad, Samira Kafala Noakes and Jake Noakes, Bruno Nouril and Ksenia Yachmetz Nouril, Hamid and Doris Nourmand, Sammy and Shaeda Nourmand, Joakim Olsson, Eric Rachlis, Steve Rose, Philip Shalam, Jonathan Stone, Caroline Theakstone, Darren Thomas and Jeff Wendt.

ADDITIONAL CAPTIONS

p.2: A distinctive broad brim black felt picture hat with the addition of a flowing silk band, lightening the all-black costume Hepburn wore as Holly Golightly in *Breakfast at Tiffany's*. p.4: The wide, turned down brim of this model hat conveys an air of mystery in its elegant simplicity. Sculpturally embellished with a large felt bow. *Vogue*, 15 August 1964. *Photograph by Cecil Beaton*. p.6: The 1960s pillbox was a shape that Audrey Hepburn wore time and again. p.8: A variation of the popular 1950s Juliet cap worn by Audrey Hepburn as Princess Ann in *Roman Holiday*. It was a style Dior chose for many of his New Look ensembles. p.11: One of the hats Audrey chose from Givenchy for her role as *Sabrina*. This close-fitting mesh cocktail hat scattered with rhinestones, topped with a silk crown, went with the little black satin dress she wore in the 1954 movie. p.13: Audrey Hepburn and George Peppard browse through jewellery at Tiffany's department store in a scene from *Breakfast at Tiffany's*, 1961. She wears the much copied mink hat and orange coat by Givenchy plus her own addition — the famous black sunglasses. p.105: Cecil Beaton purposely accentuated Audrey Hepburn's square jaw by choosing a straw boater, because it allowed for a more dramatic transformation from gawky flower girl to elegant lady. *Photograph by Cecil Beaton* Opposite: Audrey Hepburn and Maurice Chevalier contemplate a mountain of straw boater hats at the Ritz Hotel, London, in a publicity shot for the 1957 movie, *Love in the Afternoon*.

SOURCE MATERIAL

Anderson, Robert, *Fifty Hats That Changed the World* (Conran Octopus, 2011); Clark, Fiona, *Hats* (Batsford, 1982); Clarke Keogh, Pamela, *Audrey Style* (Aurum, 1999); Collector's Weekly, *Vintage Hats* <http://www.collectorsweekly.com/hats/overview> accessed January 2013; *Fashion Model Directory, The* <http://www.fashionmodeldirectory.com> accessed January 2013; Gristwood, Sarah, *Breakfast at Tiffany's: The Official 50th Anniversary Companion* (Pavilion, 2012); Jones, Stephen & Cullen Oriole, *Hats: An Anthology* (V&A Publishing, 2012); McDowell, Colin, *Hats: Status, Style and Glamour* (Thames & Hudson, 1992); Miller, Frank, *My Fair Lady* <http:// www.tcm.com/tcmdb/title/84310/My-Fair-Lady/articles.html> accessed January 2013; Museo Salvatore Ferragamo, *Audrey Hepburn, A Woman, The Style* (Arte Leonardo, 1999); Nourmand, Tony, *Audrey Hepburn: The Paramount Years* (Boxtree, 2006); Vermilye, Jerry, *The Complete Films of Audrey Hepburn* (Citadel, 1997); Walford, Jonathan, *The History of Women's Hats* <http://vintagefashionguild.org/fashion-history/the-history-of-womens-hats> accessed January 2013.

INDEX

PHOTO CREDITS

JUNE MARSH

June Marsh has been involved in writing about fashion for more than 40 years. She is the former fashion editor of the *Daily Mail* (London) as well as former editor of the Women's Page of *Country Life* magazine and has worked as fashion editor on many other national newspapers and magazines. She co-authored *Denim: From Cowboys to Catwalks* and is author of *A History of Fashion: New Look to Now*. She lives in Greenwich, south east London.

TONY NOURMAND

Tony Nourmand is founder of Reel Art Press and editor of all R|A|P publications, including the critically acclaimed *The Rat Pack*, *Hollywood and The Ivy Look* and *The Kennedys: Photographs by Mark Shaw*. Tony has also authored a further 16 books on entertainment-related imagery, including the worldwide bestsellers, *James Bond Movie Posters*, *Audrey Hepburn: The Paramount Years* and a series of books on movie poster art by the decade and by genre.

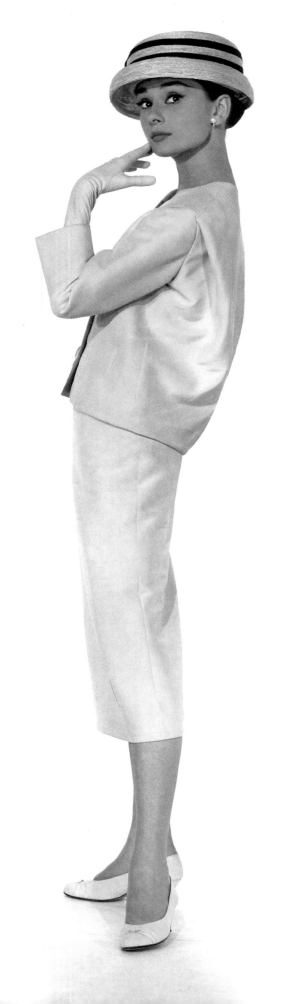